CALIFORNIA
portrait of a state

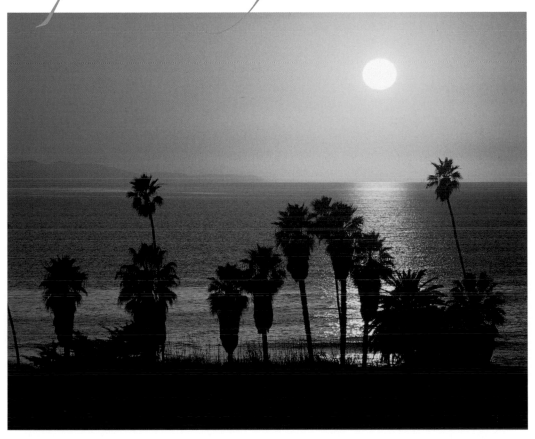

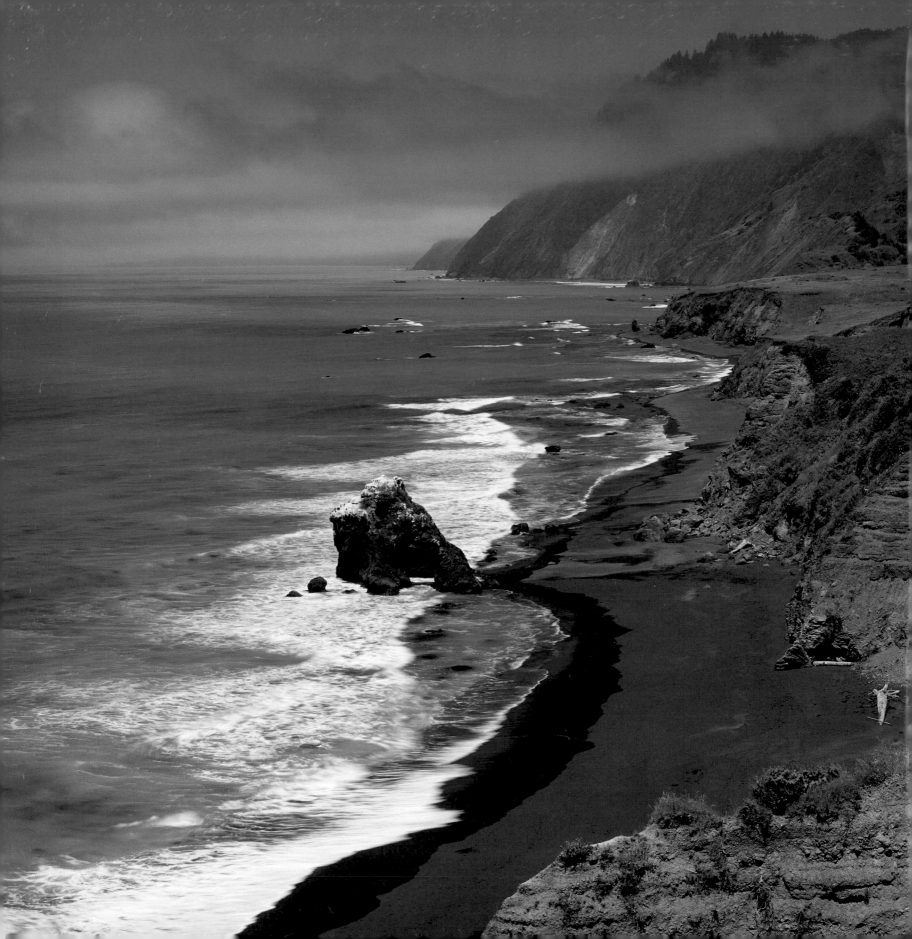

CALIFORNIA
portrait of a state

DAVID MUENCH • MARC MUENCH

Barbara & Ed,
What a lovely beginning and end
to our wonderful Canada vacation!
Thanks so much for your hospitality!
Lois & Laurie
aug. 27, '09

GRAPHIC ARTS BOOKS

All photos are by David Muench, Marc Muench, or Zandria Muench Beraldo.
For information regarding copyright of individual images, please see opposite page.

All rights reserved. No part of this book may be reproduced or transmitted in any form or by any means,
electronic or mechanical, including photocopying, recording, or by any information storage
and retrieval system, without written permission of the publisher.

Library of Congress Control Number: 2004103693
International Standard Book Number: 1-55868-848-X

Graphic Arts Books, an imprint of
Graphic Arts Center Publishing Company
P.O. Box 10306, Portland, Oregon 97296-0306
503/226-2402; www.gacpc.com

President: Charles M. Hopkins
Associate Publisher: Douglas A. Pfeiffer
Editorial Staff: Timothy W. Frew, Tricia Brown, Kathy Howard, Jean Bond-Slaughter
Production Staff: Richard L. Owsiany, Heather Doornink
Cover Design: Elizabeth Watson
Interior Design: Jean Andrews
Cartographer: Ortelius Design

Printed in the United States of America
Third Printing

◄◄ A familiar sight for Southern Californians is the ubiquitous
palm tree. Seen in various forms, here several trees are silhouetted
against a Santa Cruz Island sunset over the Santa Barbara Channel.
◄ The King Range National Conservation Area is seen from the
vantage point of Sinkyone Wilderness State Park.

PHOTO CREDITS & COPYRIGHT INFORMATION

The following photographs are © MCMXCIX by **DAVID MUENCH**: pages 2, 6, 8–9, 10, 11, 12, 14, 15, 17, 18, 20, 24–25, 29, 30, 31, 33, 34, 35, 36, 37, 38, 40–41, 42, 43, 46, 47, 48, 49, 50 left lower, 52, 55, 56–57, 58, 63, 64 left upper, left center, left lower, right lower, 65, 66, 67, 70, 72–73, 74, 75, 76, 77, 82, 83, 84, 85, 86, 93, 94, 95, 96, 98, 99, 100, 102, 103 left upper, right upper, right lower, 104, 105, 106, 107, 108, 109, 110, and 111.

The following photographs are © MCMXCIX by **MARC MUENCH**: pages 1, 7, 13, 16, 19, 21, 22, 23, 25, 26, 27, 28, 32, 39, 44, 45, 50 left upper, left center, right upper, right lower, 51, 53, 54, 59, 60, 61, 62, 64 right upper, 68, 69, 71, 78, 79, 80, 81 left upper, left lower, right upper, right center, right lower, 87, 88–89, 90, 91, 92, 97, 101, 103 left lower, and 112.

The following photograph is © MCMXCIX by **ZANDRIA MUENCH BERALDO**: page 103 right center.

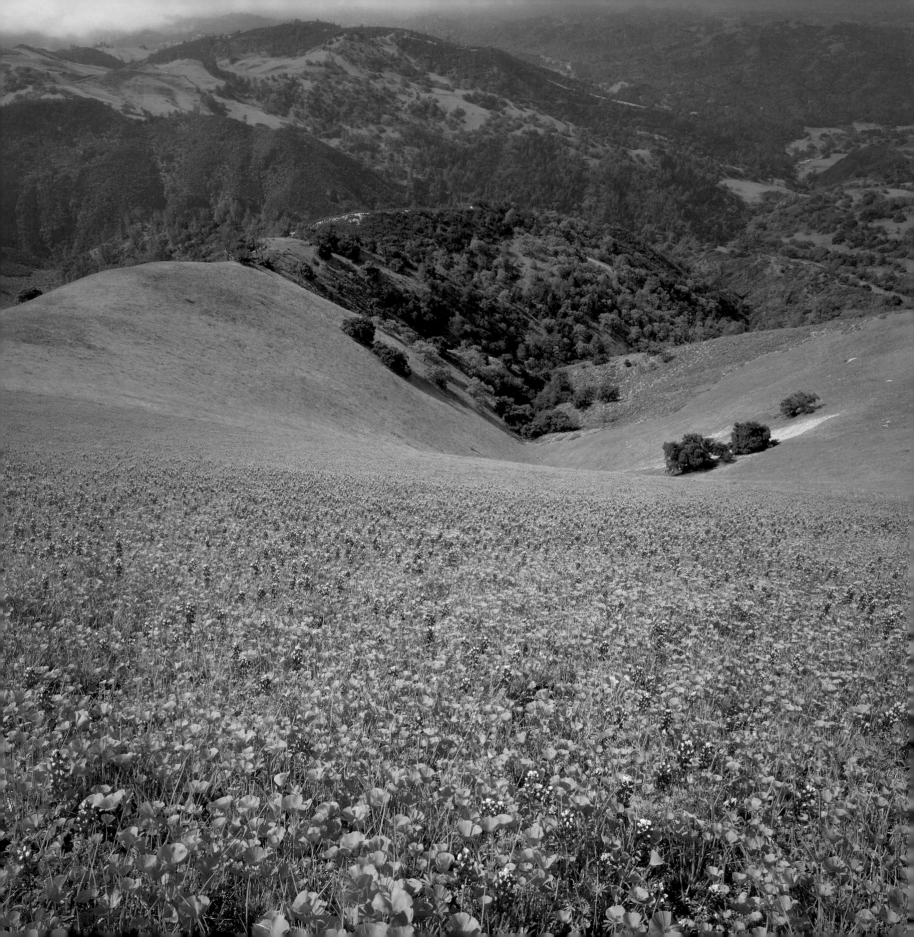

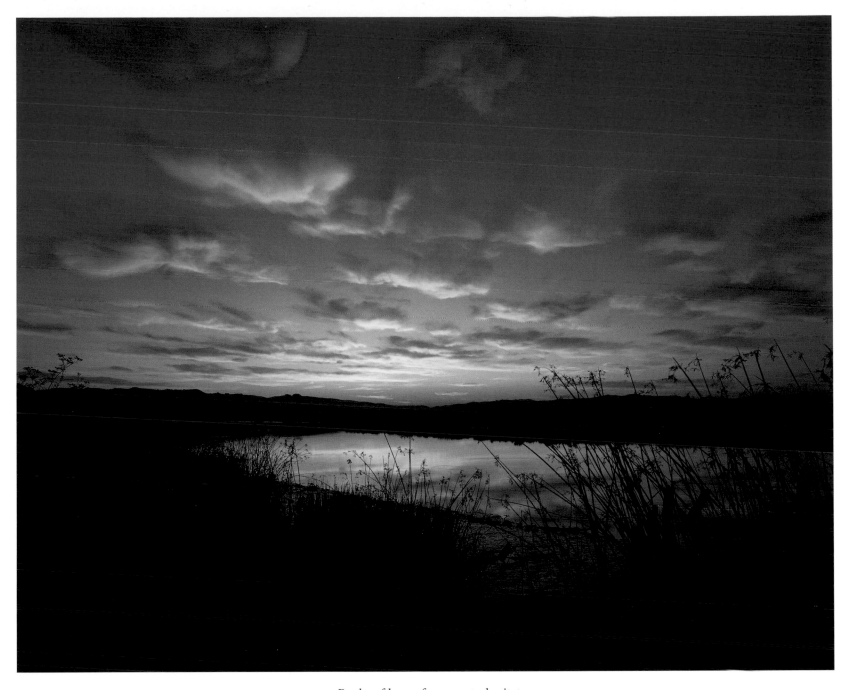

◄ Banks of heavy fog seem to hesitate
at an invisible wall as they roll onto the western
Santa Ynez slope, wild with California poppies and lupine.
▲ Giant bulrushes *(Scirpus californicus)* conduct a symphony of
sunrise colors in wetlands of Napa River tidal waters in
the Napa/Sonoma Marsh Wildlife Area.

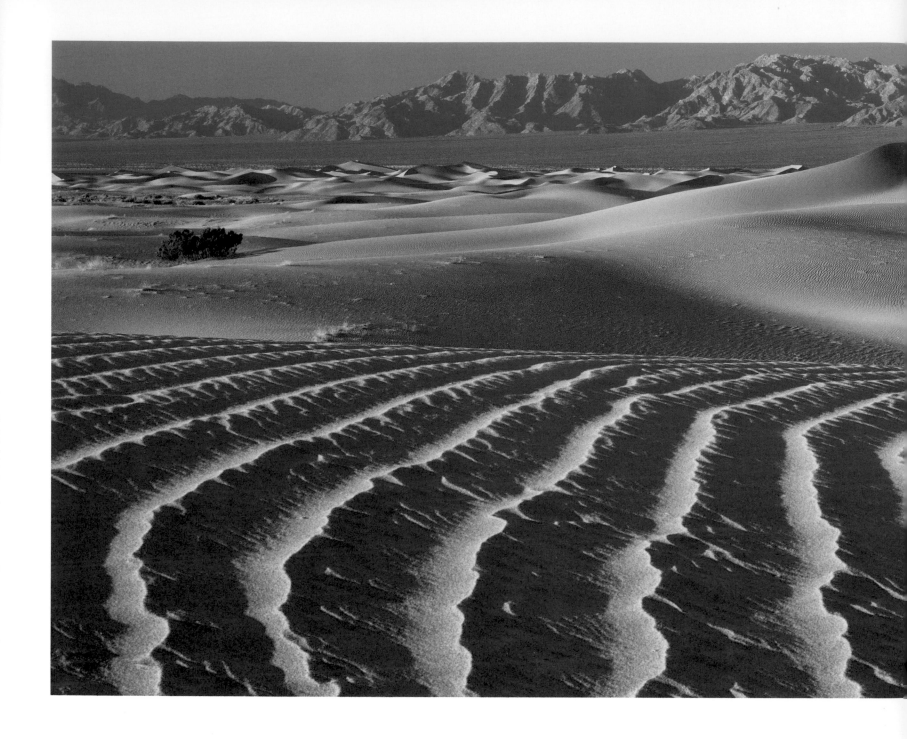

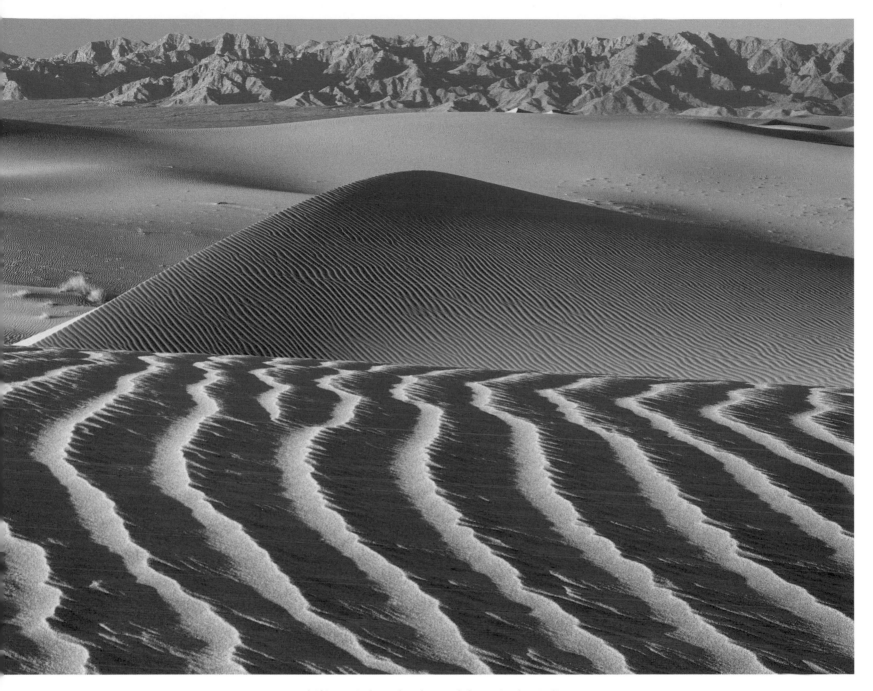

▲ Shifting winds sculpt the sand dunes in the Cadiz Dunes
Wilderness of the Mojave Desert.

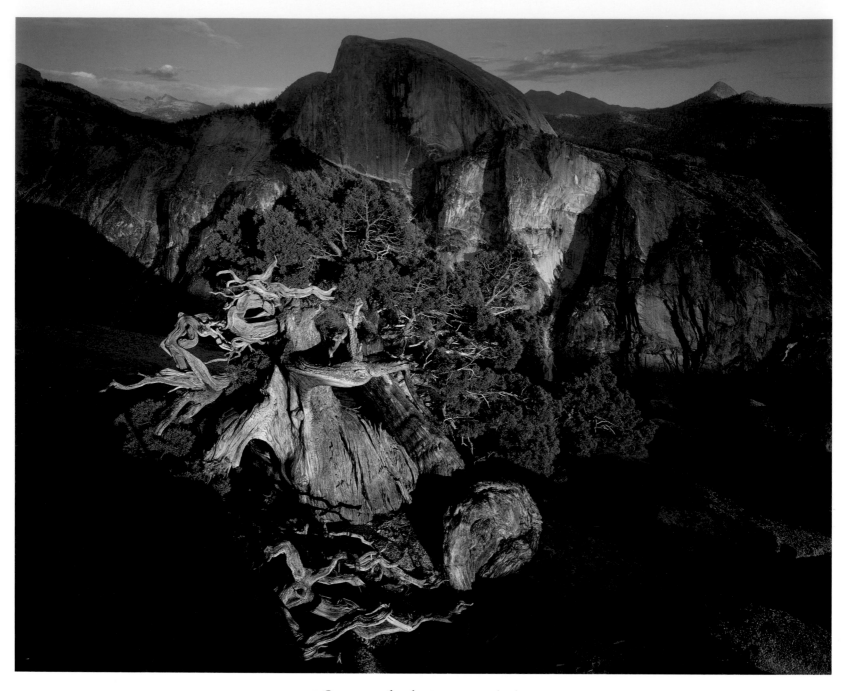

▲ Craggy, weather-beaten western juniper
(Juniperus occidentalis) braves the elements among
glacially carved granitic domes and cliffs of the Sierra Nevada.
Half Dome, in Yosemite National Park, rises in the background.
► As winter gives way to summer, ice floes break up in Young
Lakes, casting a double image of Mount Conness
(12,590 feet), in Yosemite's high country.

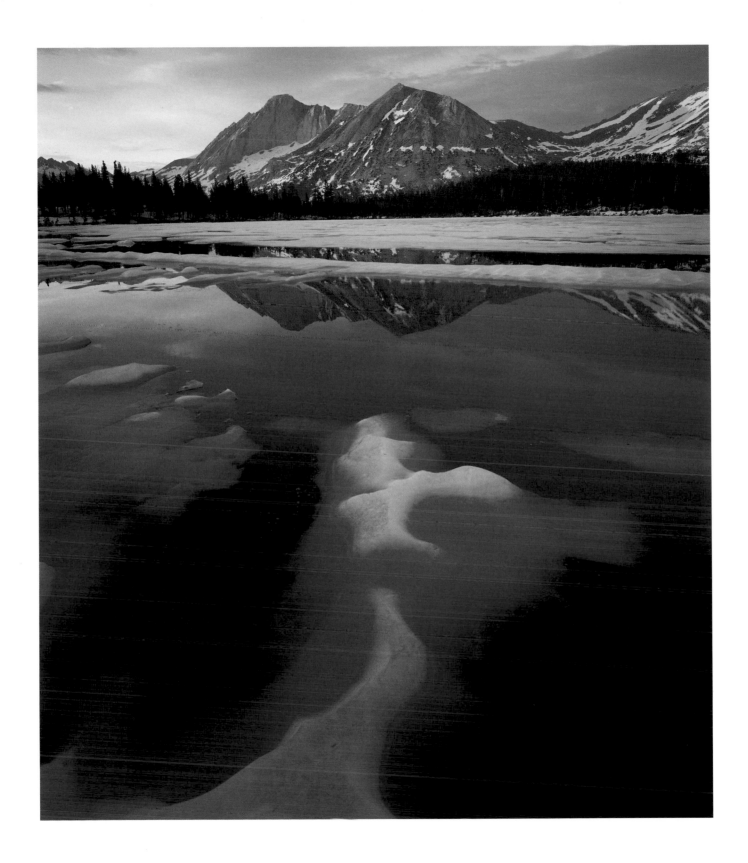

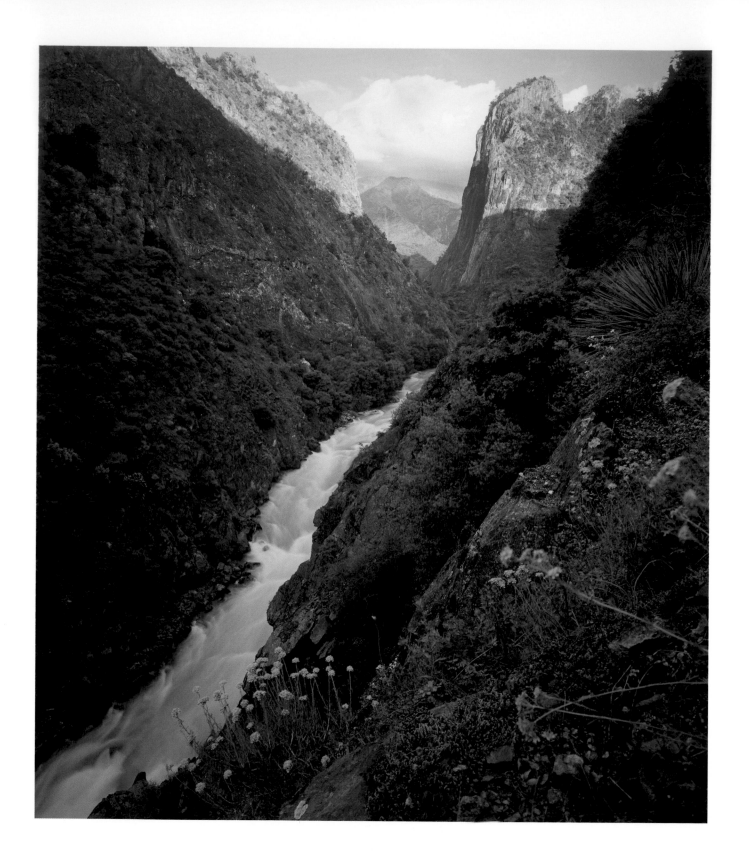

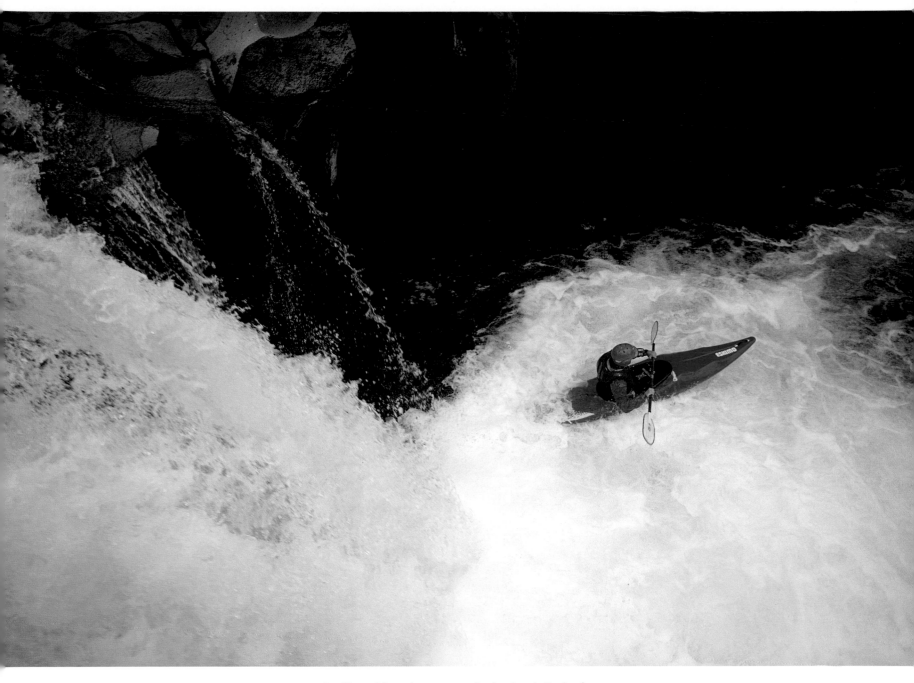

◄ Swollen with spring snowmelt, the South Fork of
the Rio de los Santos Reyes (River of the Holy Kings)
as named by Spanish explorers in 1805, passes through
a glacially sculpted gateway to Kings Canyon National Park.
▲ After navigating the waterfall to the left, a lone kayaker heads down
the McCloud River, one of many outdoor sports areas accessible from the
nearby town of Mount Shasta in the Cascade Range of Northern California.

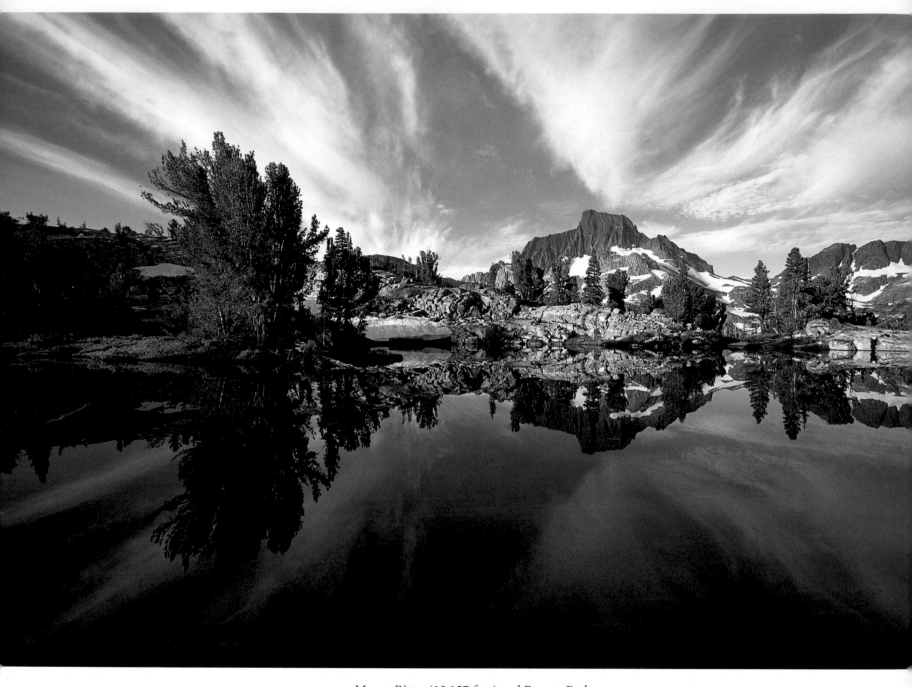

▲ Mount Ritter (13,157 feet) and Banner Peak
(12,945 feet) hold the high ground in the horizontal
symmetry of an alpine pond reflection at Thousand Island
Lake, in the Ritter Range, Ansel Adams Wilderness, below Yosemite.
▶ Peaks of the Monarch Divide tower above the South and Middle Forks of
Kings River Canyon. Buckeye *(Aesculus californica)* adds June color
to the sheer rock walls of this Sequoia National Forest locale.

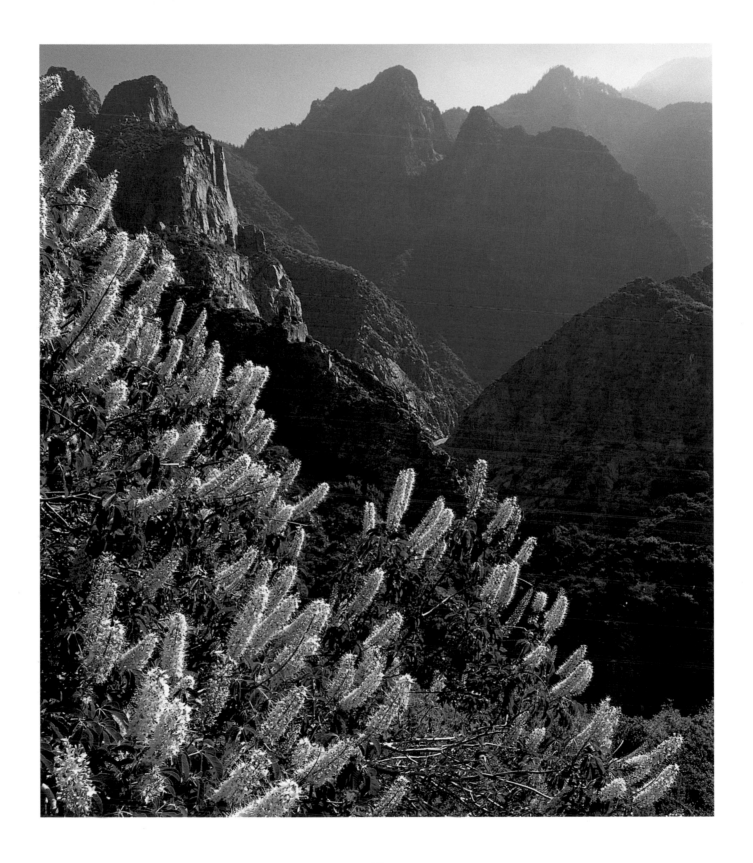

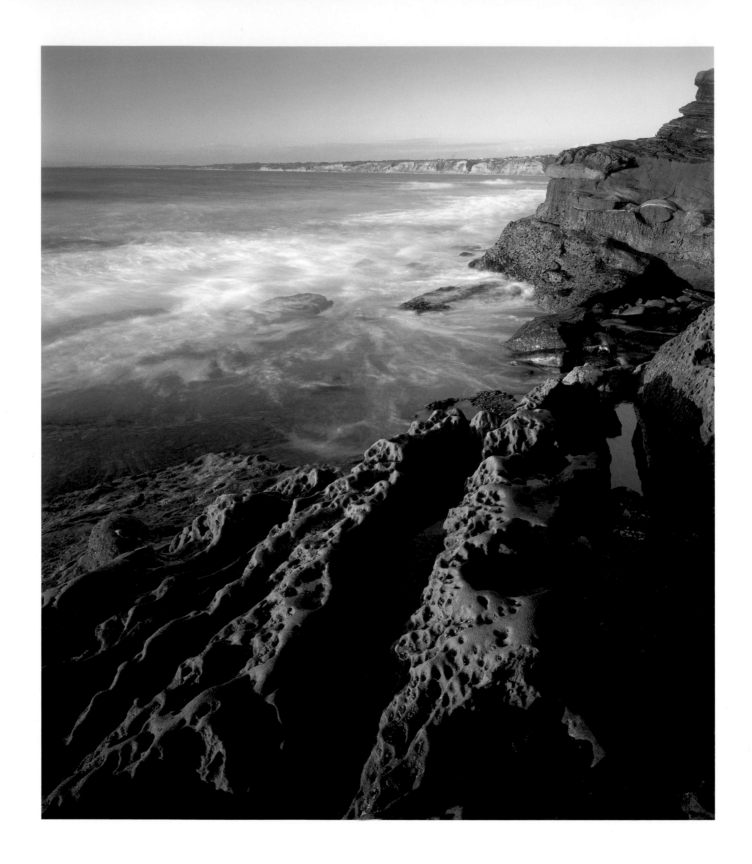

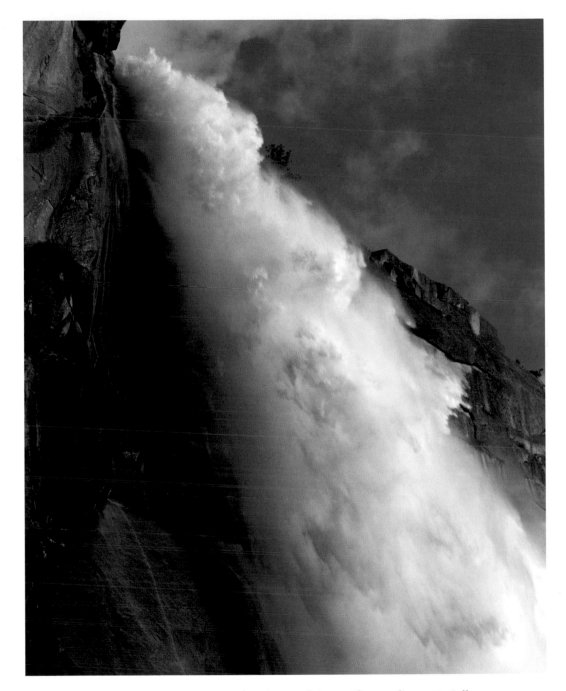

◄ Waves break along the rocky shores of the Pacific coastline at La Jolla.
▲ Cascading plumes seem to explode from the granite shelf to become
Nevada Falls along the Merced River in Yosemite National Park.

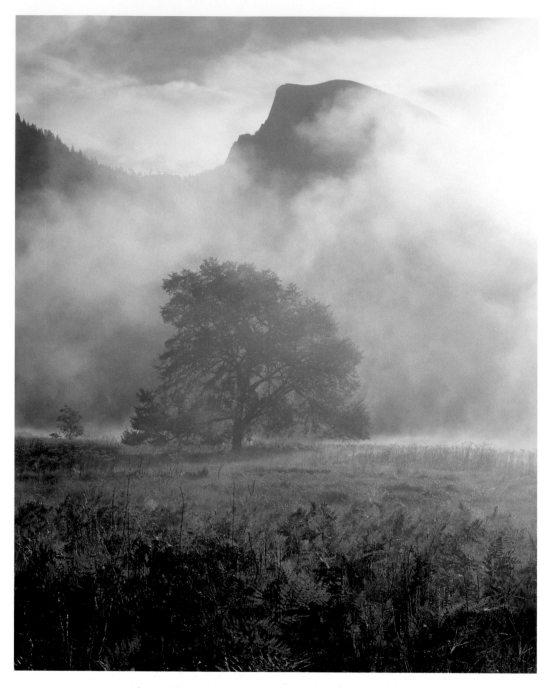

▲ A sleepy black cottonwood *(Populus balsamifera)* pulls aside
the morning veil from Half Dome's monolithic
north granite wall in Yosemite Valley.

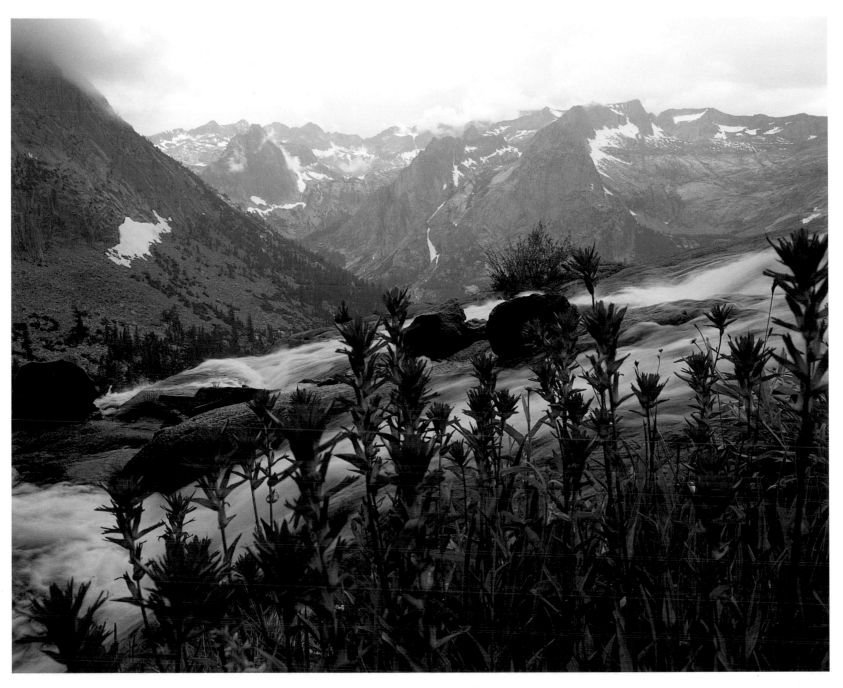

▲ As Sierra storms quickly come and go, blooms of paintbrush
(Castilleja indivisa) stand along the Dusy Basin,
Middle Fork of the Kings River.

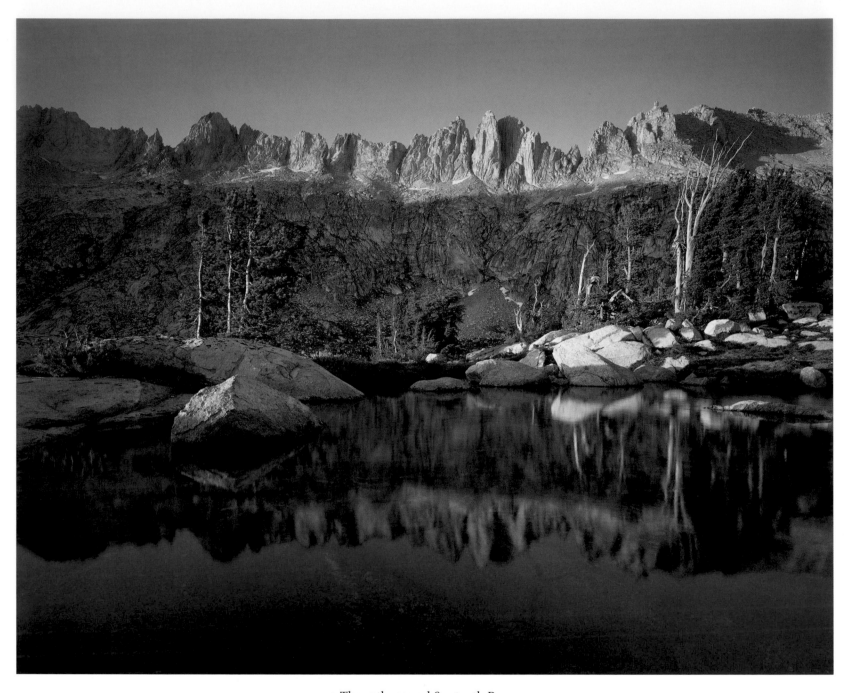

▲ The aptly named Sawtooth Range
echoes a stand of whitebark pine *(Pinus albicaulis)* at
timberline along the head of Piute Creek, Yosemite National Park.
▶ The conservationist legacy of John Muir lives on along the trail named
after him. Hikers wend their way above Le Conte Canyon en route to
Muir Pass, halfway between Mount Whitney and Yosemite Valley.

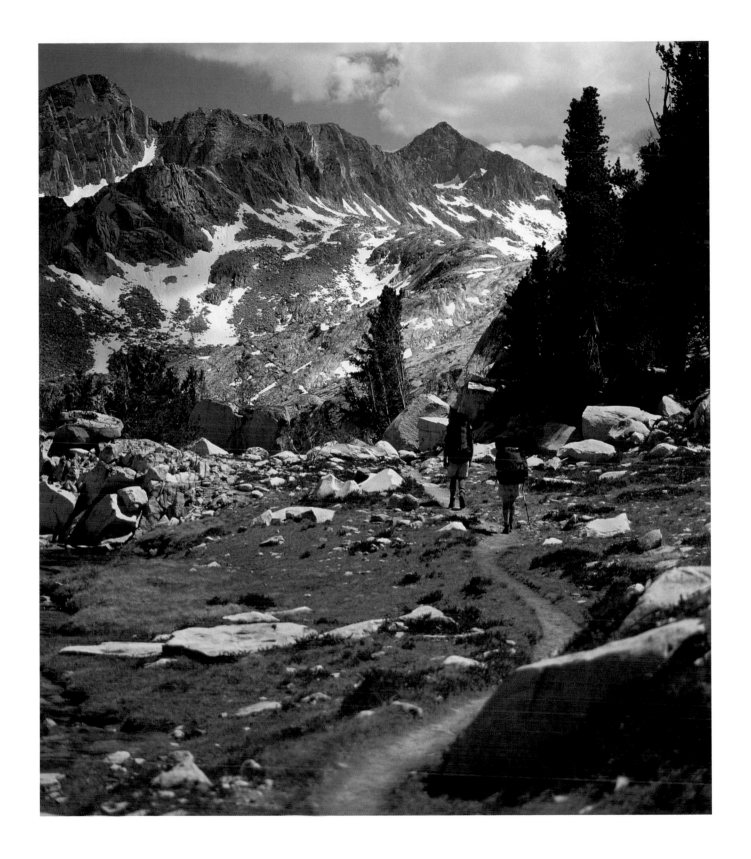

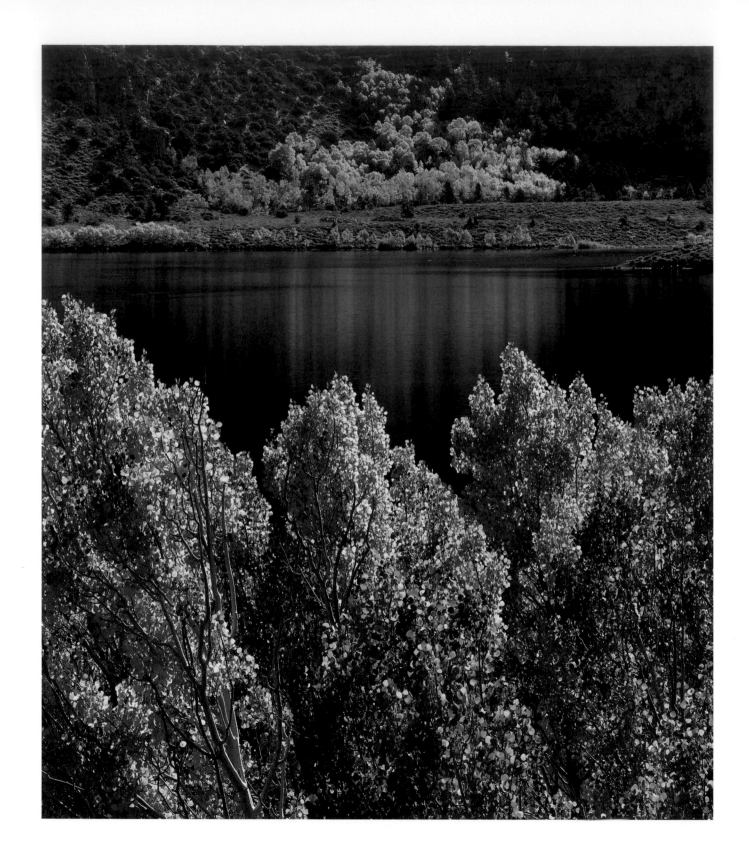

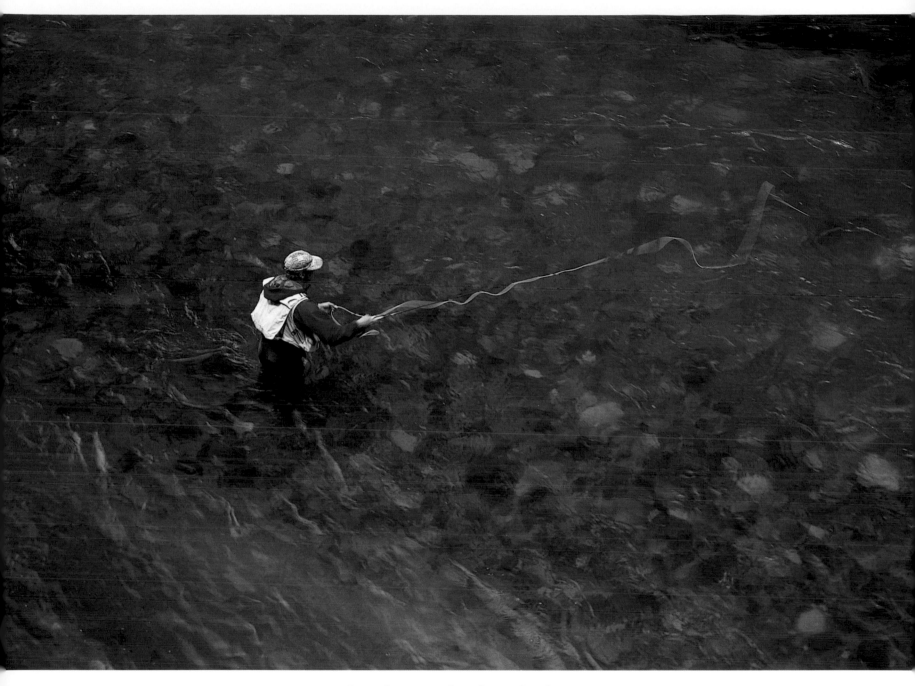

◄ Pastoral autumn colors glow against the
cool palette of Grant Lake along the June Lake
Scenic Loop, south of Tioga Pass in the Eastern Sierra.
▲ The life-giving waters of the Upper Sacramento River provide
ample opportunities for brown trout fly-fishing.

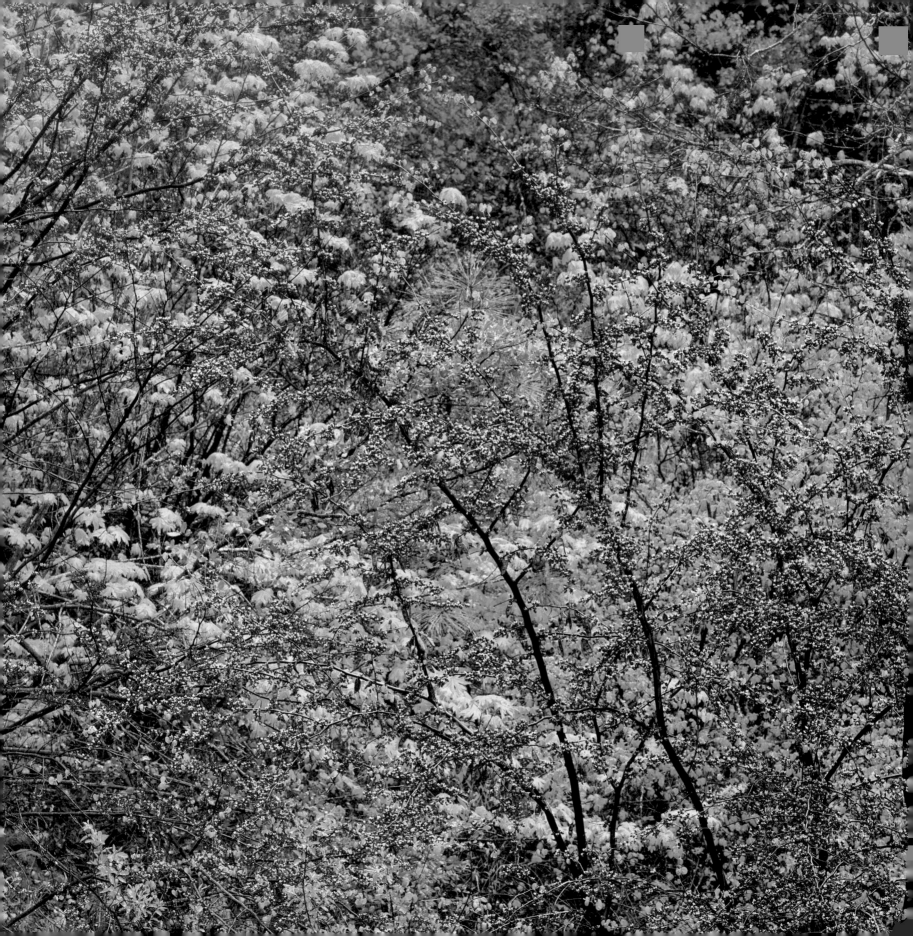

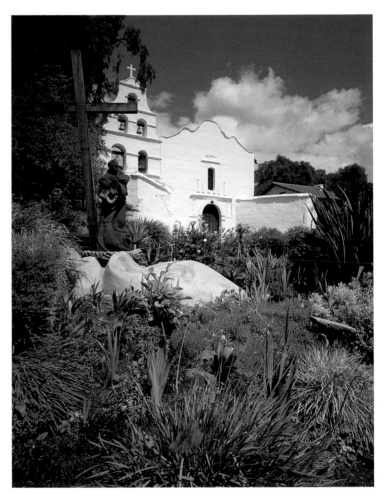

◄ California redbud provides brilliant contrast to
bigleaf maple in the McCloud River Canyon Preserve.
▲ Founded by Spanish missionary Father Junípero Serra
in 1769, Mission San Diego de Alcala, was the first
of California's twenty-one Catholic missions.

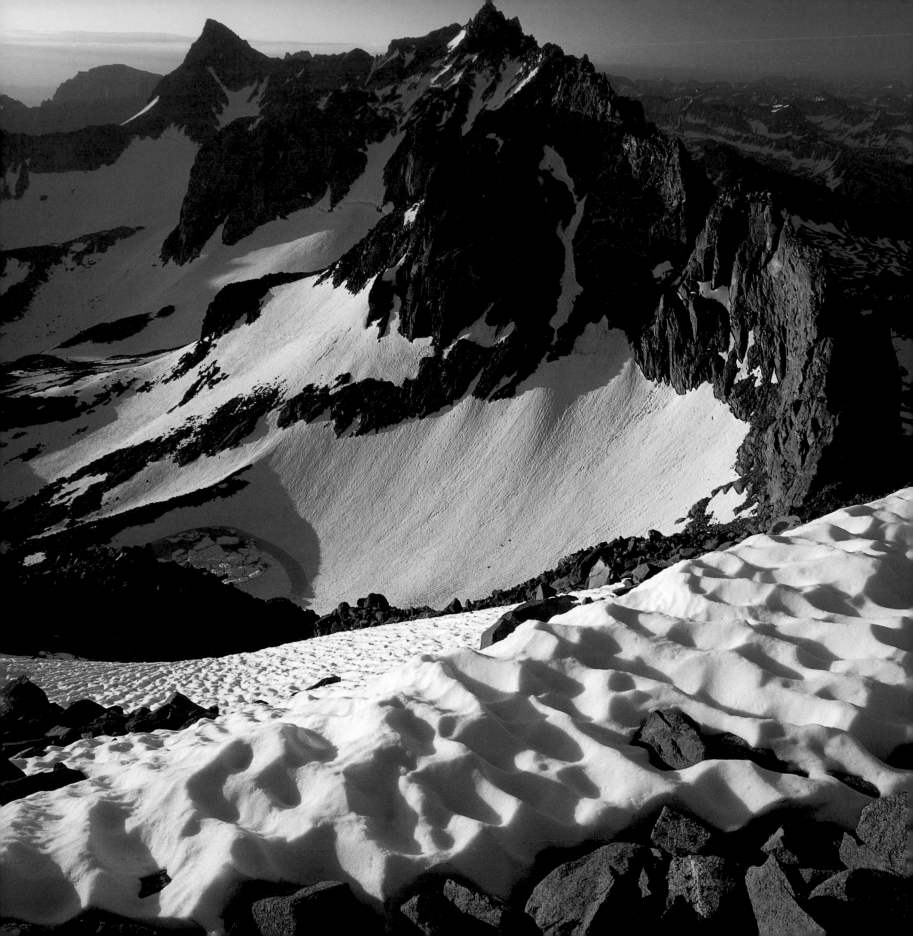

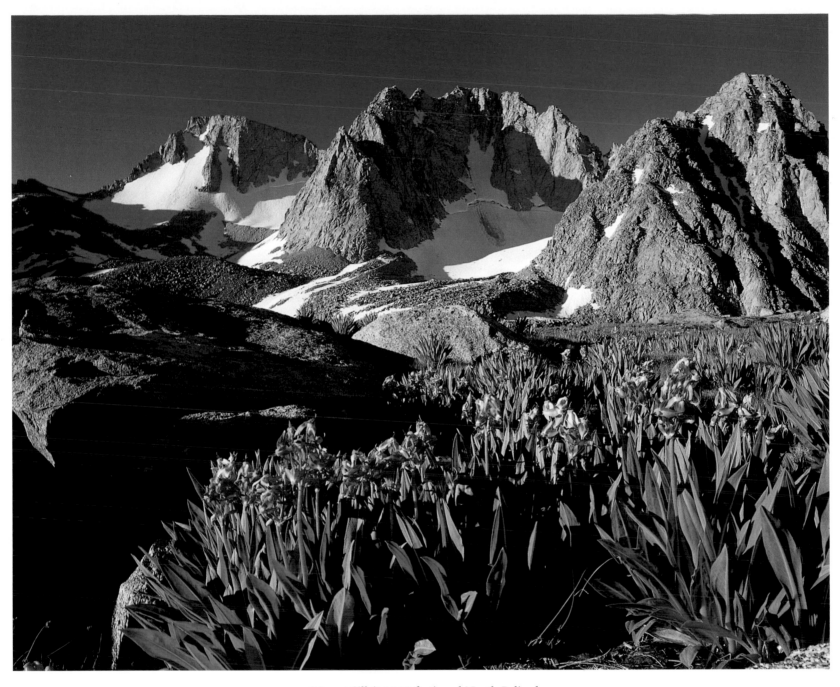

◄ Mount Sill (14,153 feet) and North Palisade
(14,242 feet) tower above the Palisade Glacier, as
seen from the top of Mount Aggasiz (13,883 feet).
▲ Alpine shooting stars *(Dodecatheon alpinum)* add grace
to the imposing might of Mounts Darwin (13,381 feet) and
Mendel (13,170 feet), in the 462,000-acre Kings Canyon National Park.

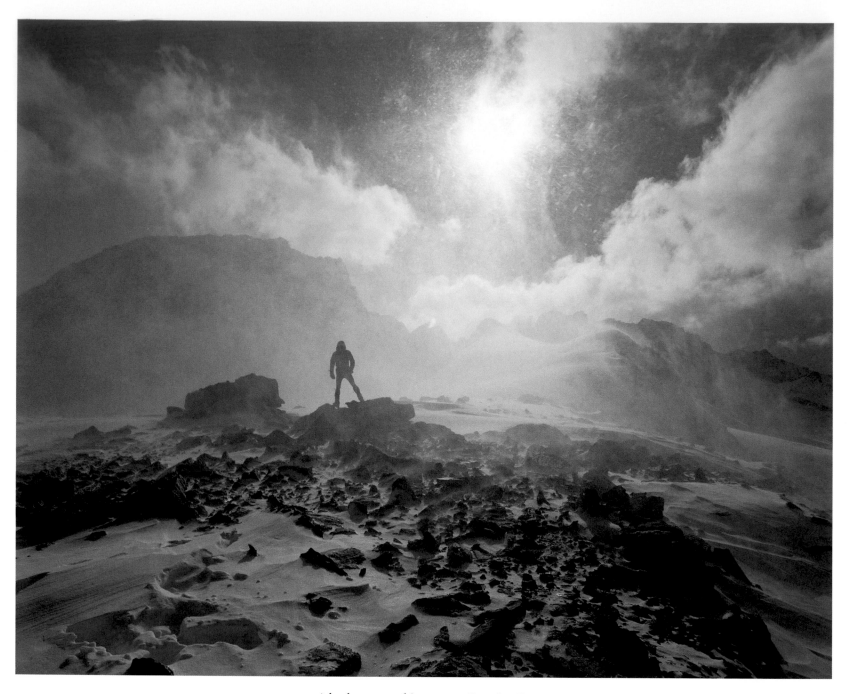

▲ A backcountry skier rests at Junction Pass
(13,000 feet) in the High Sierra of Kings Canyon National Park.
► Fiery sunset colors silhouette hardy, ancient foxtail pines clinging to life
on Alta Peak's windy granite slopes in Sequoia National Park.

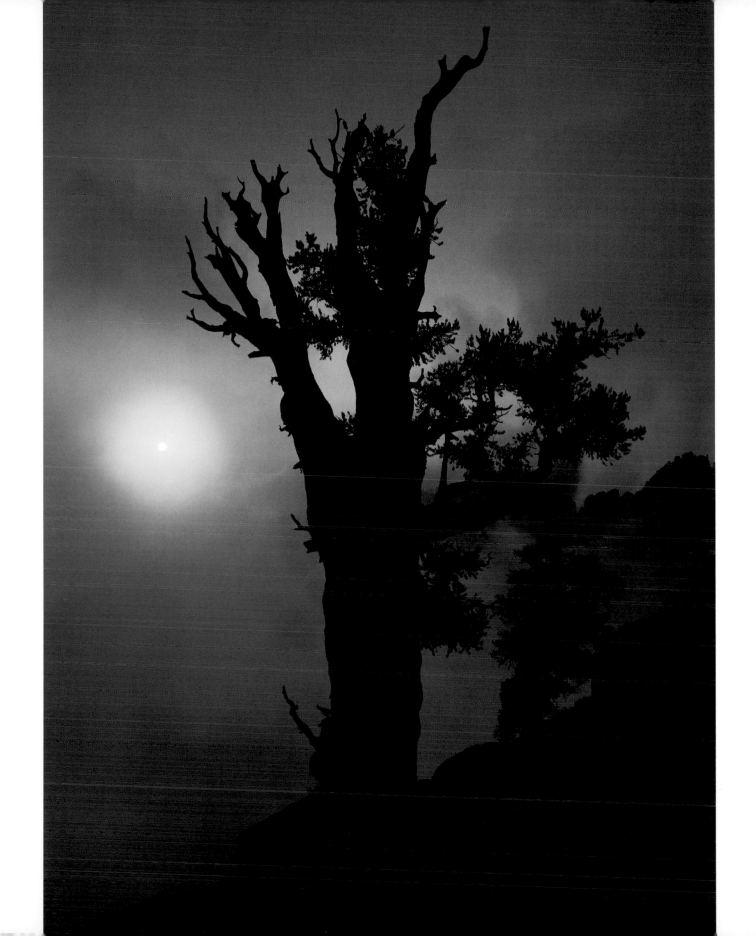

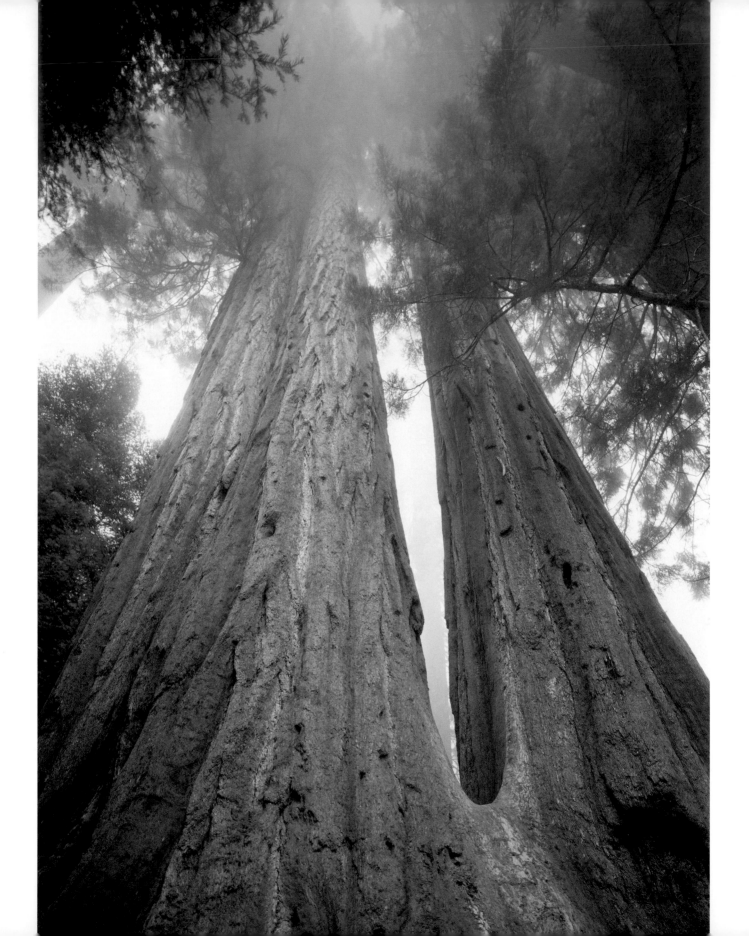

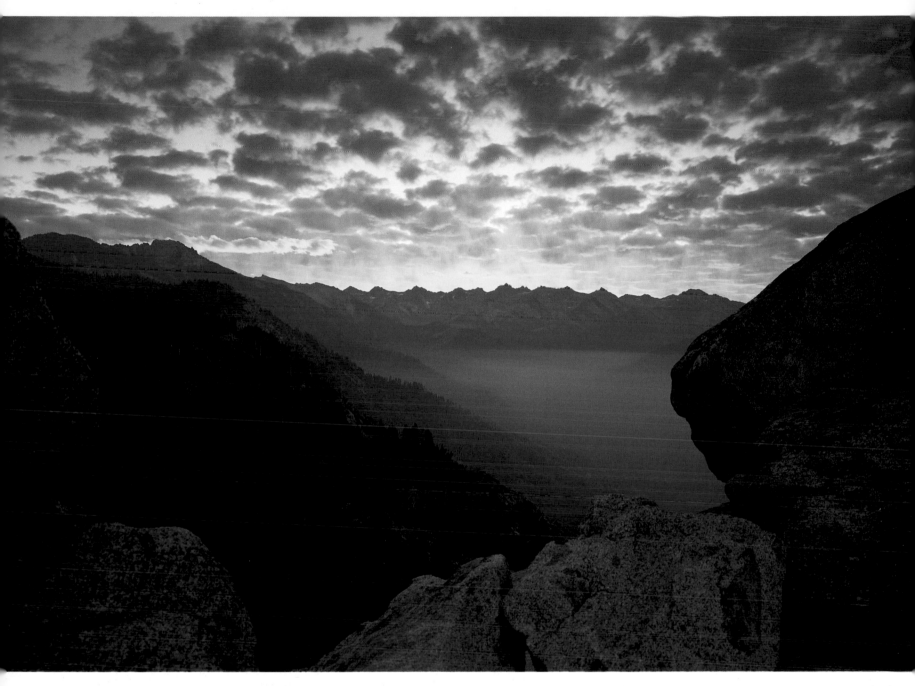

◄ In the Giant Forest section of Sequoia National Park,
the massive trunks of sequoias reach majestically into the mists.
▲ Dawn light explodes above the Great Western Divide along
the fog line from Moro Rock in Sequoia National Park.

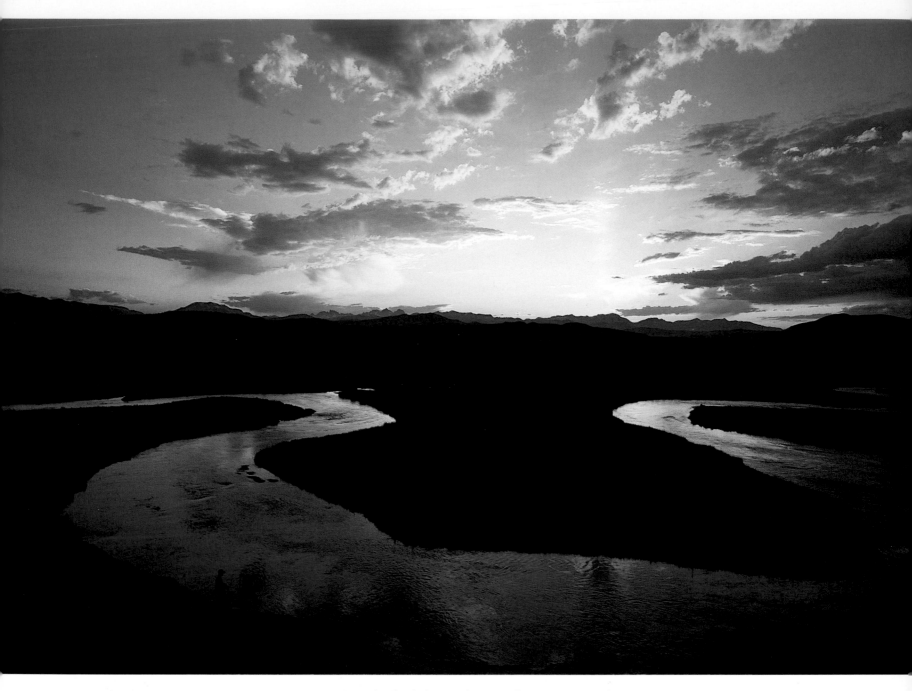

▲ Evening splendor lights up the meandering Owens River to
reveal a boy fishing for trout. Mammoth Mountain, the Minarets,
and Mounts Ritter and Banner line the horizon.

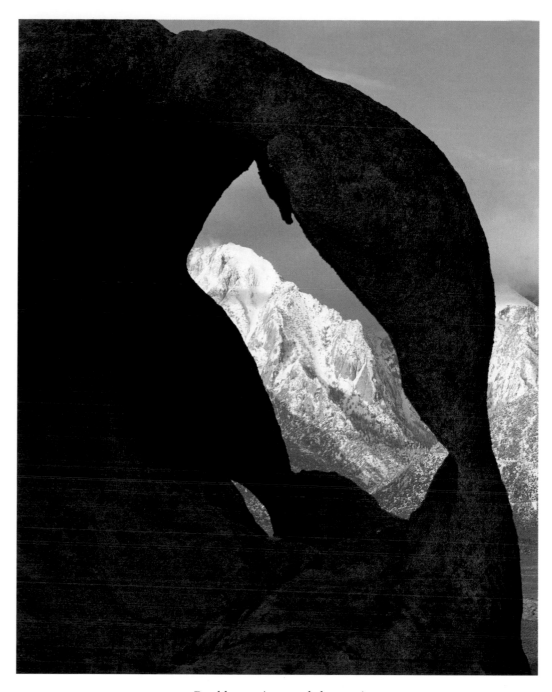

▲ Double openings made by granite
arches in the Alabama Hills frame peaks along the
eastern slope of the Sierra Nevada in winter.

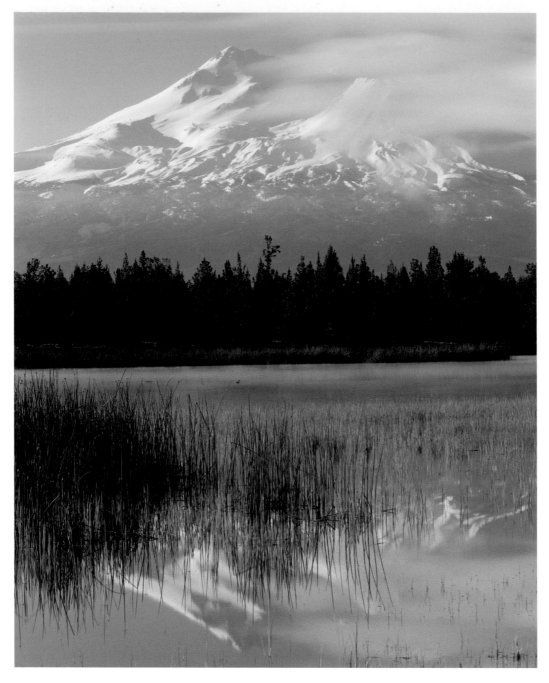

▲ The gossamer enigma of Mount Shasta
(14,162 feet) and Shastina (12,330 feet) adds mystery
to the skies and pond waters along the Little Shasta River.
► Blossoms of the flowering dogwood *(Cornus nuttalii)*
weave a galaxy of May splendor around a
Douglas fir *(Pseudotsuga menziesii)*.

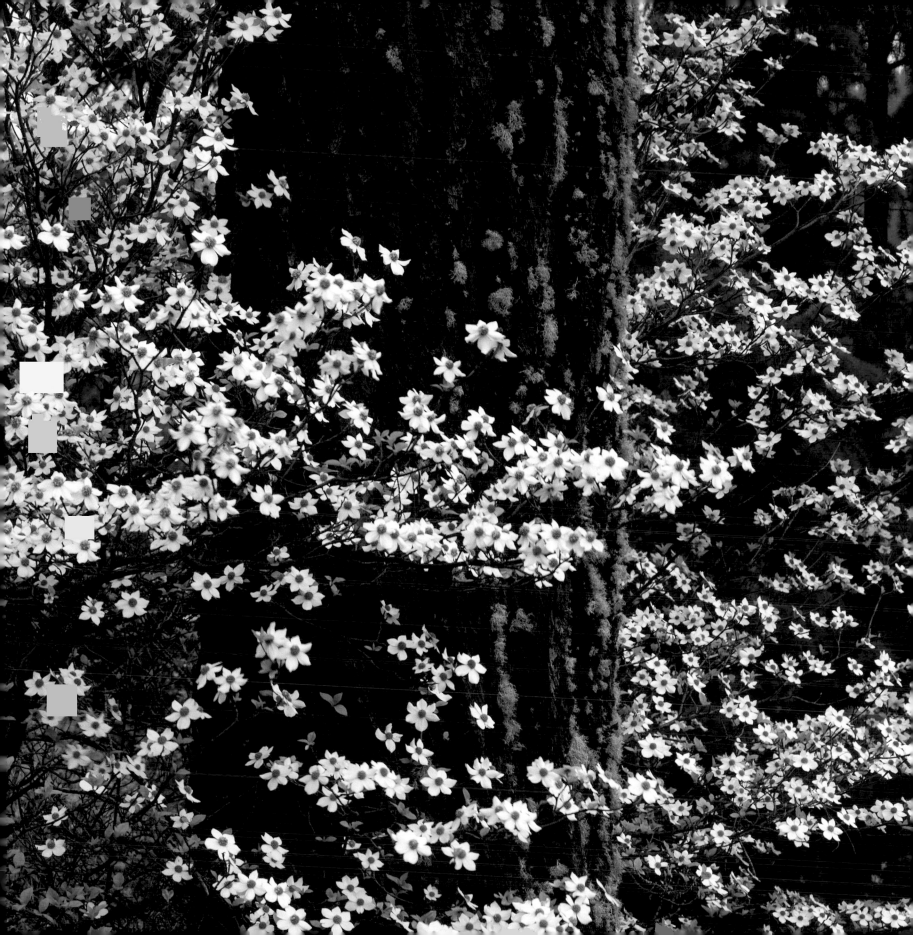

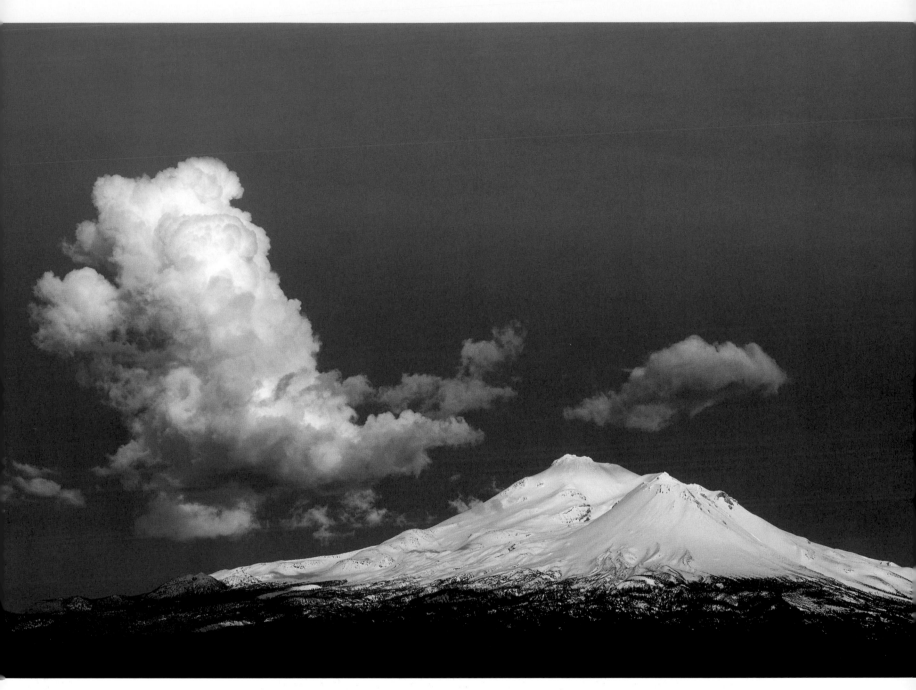

▲ Both cloud and mountain seem to float above the ground in this
view of Mount Shasta, Northern California's giant in the Cascade Range.
► With its exuberant blooms, California redbud *(Cercis occidentalis)* adds
radiance to a quiet forest day high in the McCloud River Canyon.

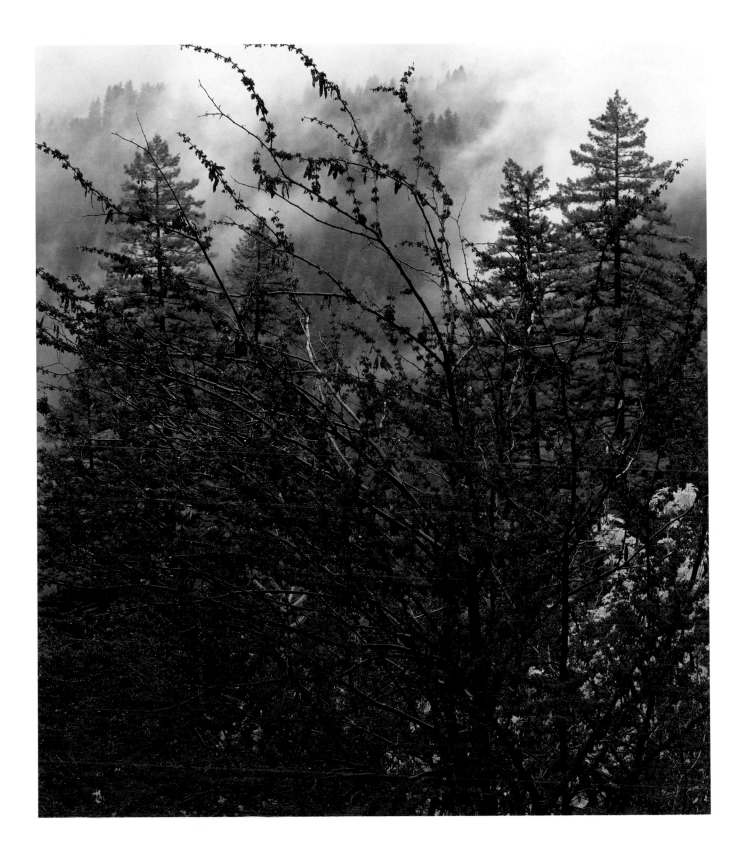

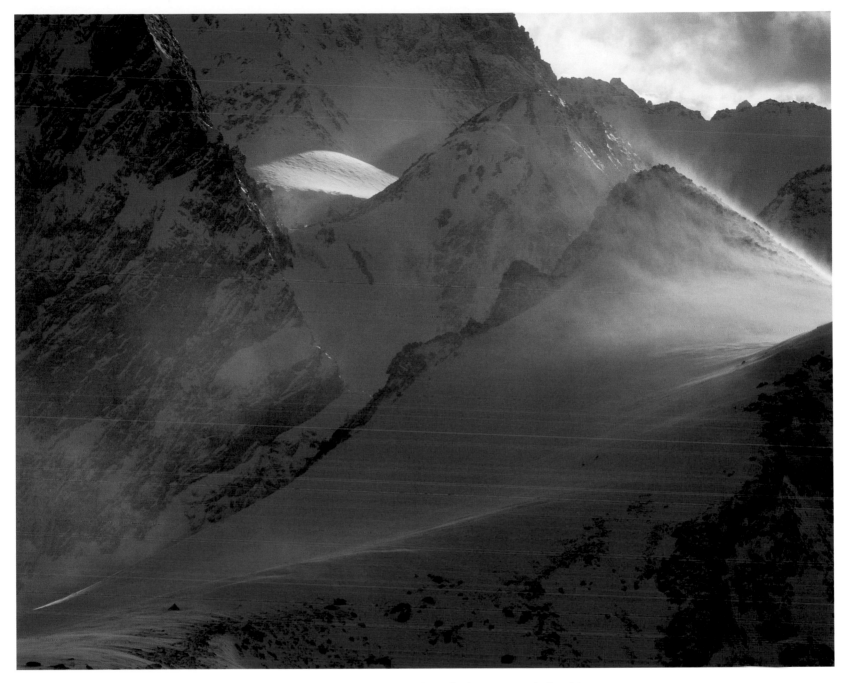

◄ An autumn blaze of bigleaf maple *(Acer macrophyllum)* is
muted into flowing warmth by rain- and cloud-diffused light along
the Middle Fork of the Smith River, Smith River National Scenic Area.
▲ High winds blast a solitary tent perched on Junction Pass, above Kings
Canyon. With just one road leading into Kings Canyon National Park,
most of its 722 square miles is wilderness, accessible only by trail.

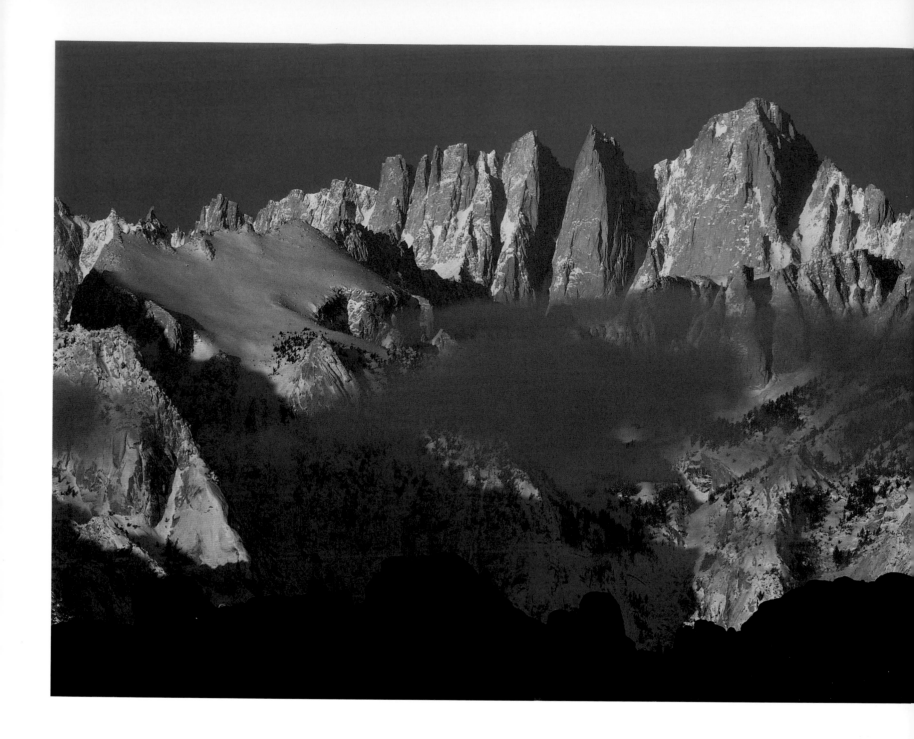

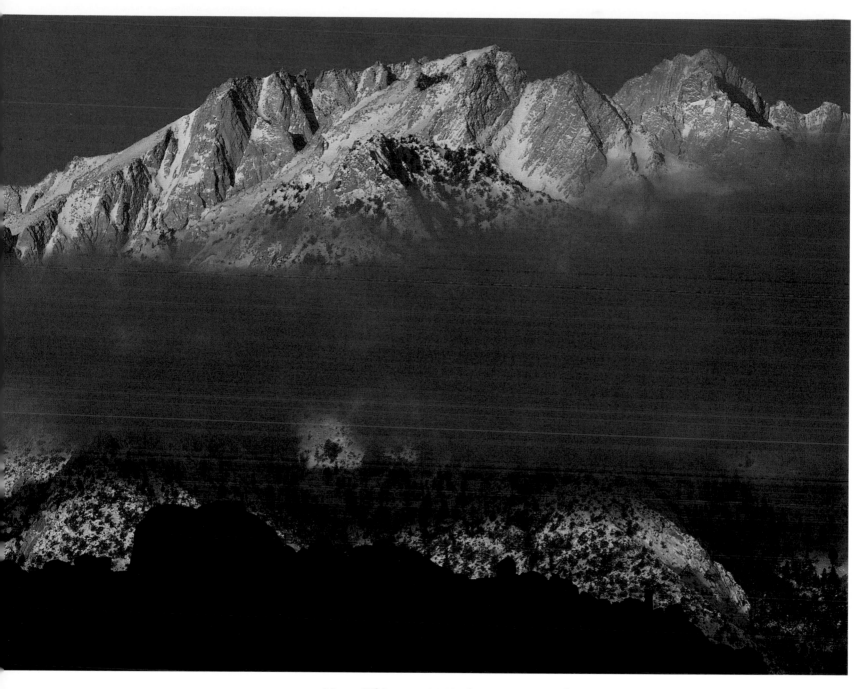

▲ Mount Whitney, at 14,496 feet, cuts a serrated
granite skyline along the eastside Sierra Nevada between
Sequoia National Park and the John Muir Wilderness.

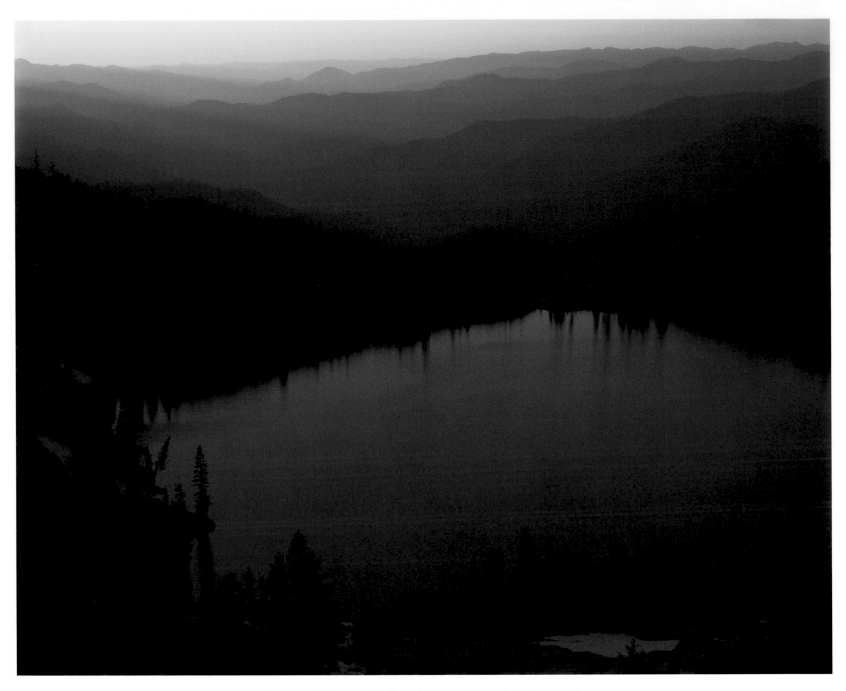

▲ Reflected in Lower Caribou Lake, soothing alpine hues soften
the glacial landscape of the Trinity Alps Wilderness, at the
headwaters of the South Fork of the Salmon River.

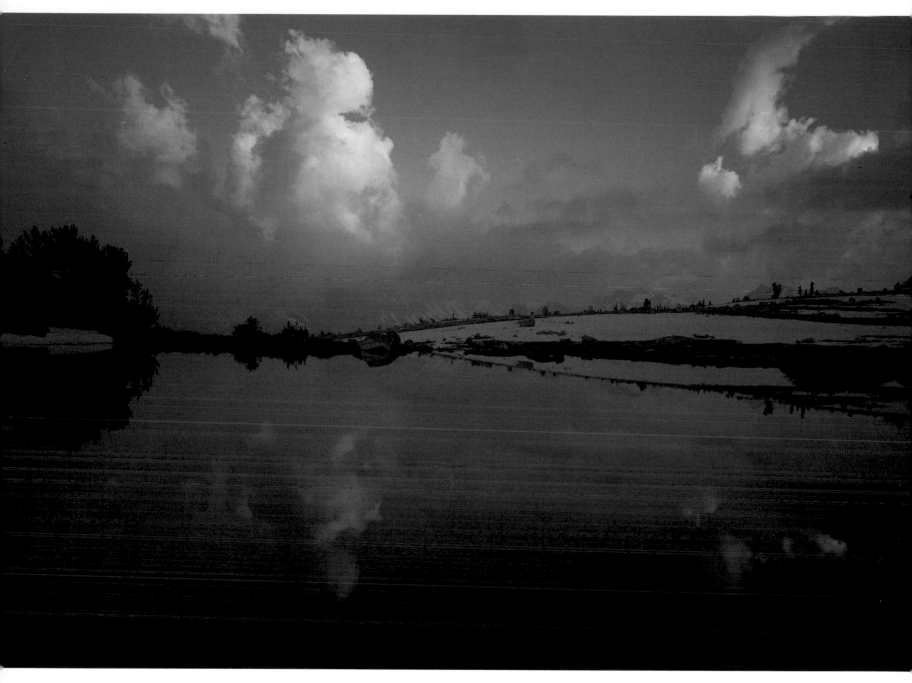

▲ Mirrored by an alpine pond in Pioneer Basin, John Muir Wilderness,
towering evening cumulus clouds shroud the snowpacked peaks
of the Sierra. With 581,000 acres, the John Muir
is the largest wilderness in California.

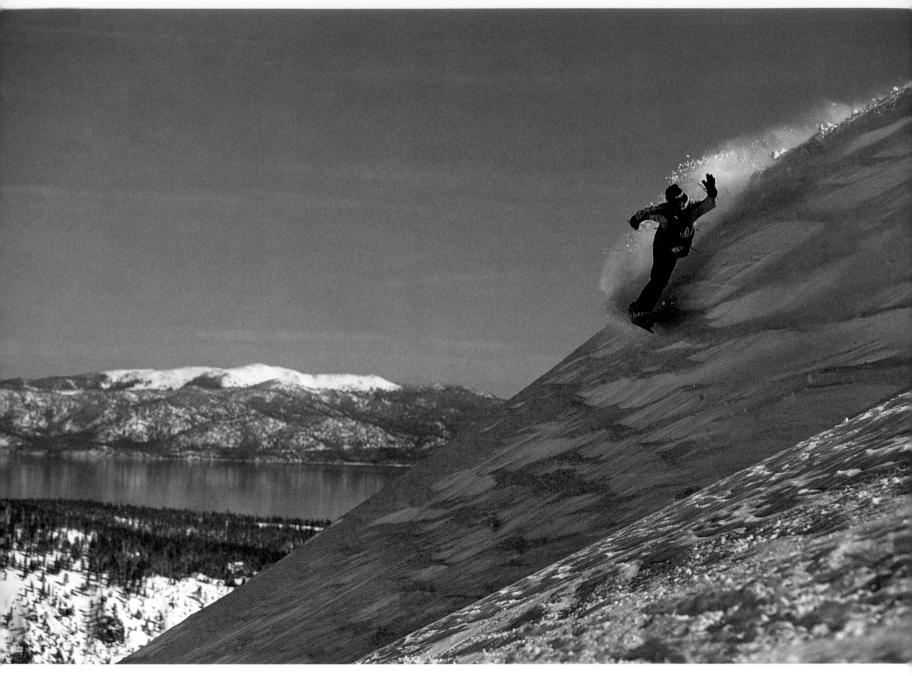

▲ A snowboarder carves up a wave of windblown
snow at Squaw Valley Ski Resort. Mount Rose, just across
the border in Nevada, anchors the horizon beyond Lake Tahoe.
► Winter snow melts away from the fractured, primordial rock face of
a cliff above Deadman Canyon, as seen from the Kings–Kaweah
Divide in Sequoia and Kings Canyon National Parks.

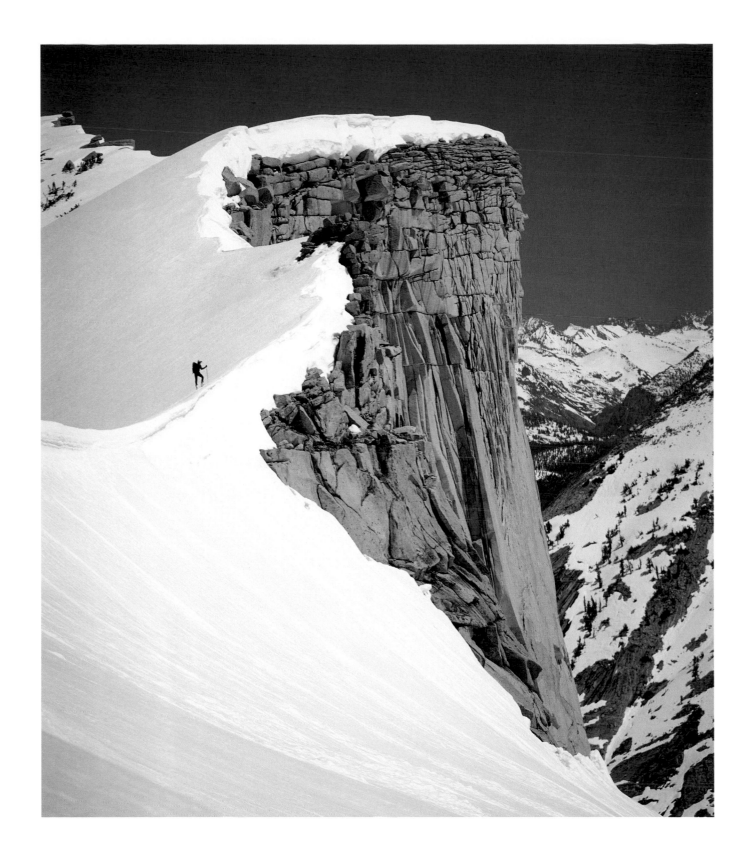

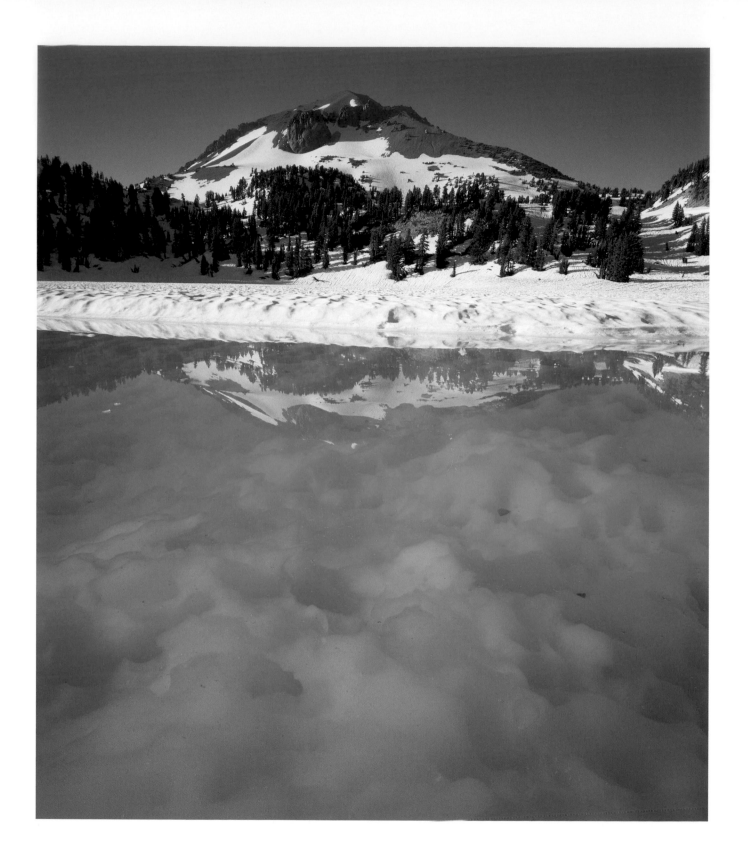

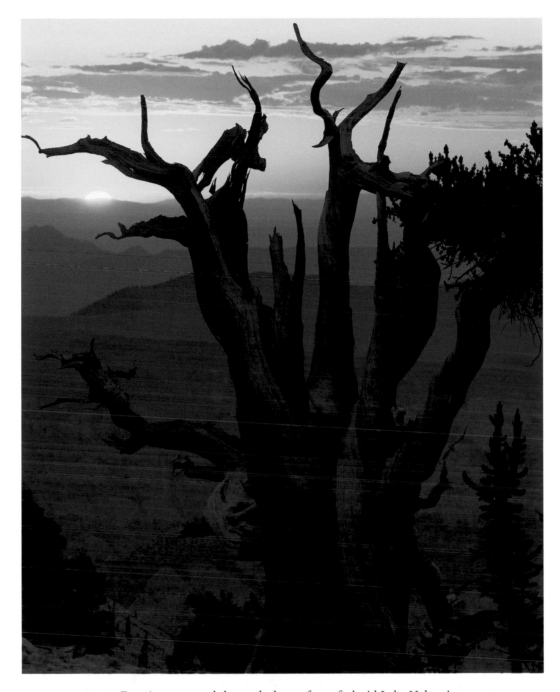

◄ Freezing snowmelt beneath the surface of placid Lake Helen, in
Lassen Volcanic National Park, evokes the Ice Age. Nearby Lassen Peak,
southernmost volcano in the Cascade Range, last blew its stack in 1915.
▲ An ancient bristlecone pine *(Pinus aristata)* of the Patriarch Grove greets
a White Mountain sunrise, as many have done for four thousand
years. Bristlecones are the earth's oldest living trees.

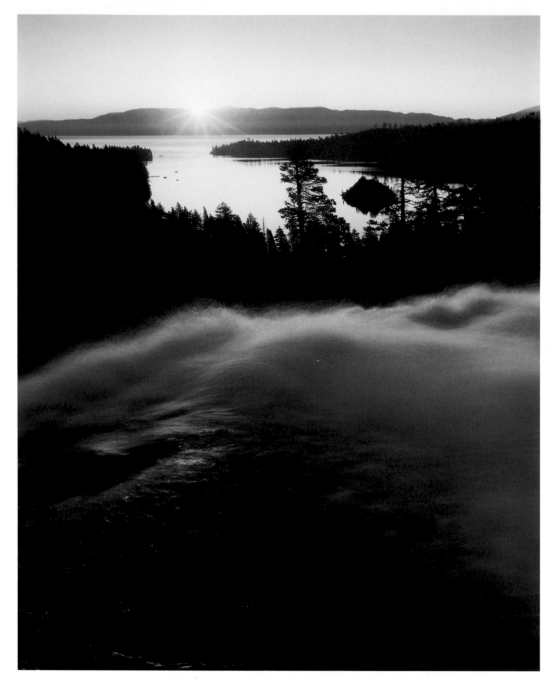

▲ Spring snowmelt from Desolation Wilderness runs over granite
cliffs on its way into Emerald Bay on the south shore of Lake Tahoe.
▶ Bush lupine *(Lupinus arboreous)* echo colorful highlights in the cool
vapors around the chaparral and forested Figueroa Mountain, in
the San Rafael Wilderness of Los Padres National Forest.

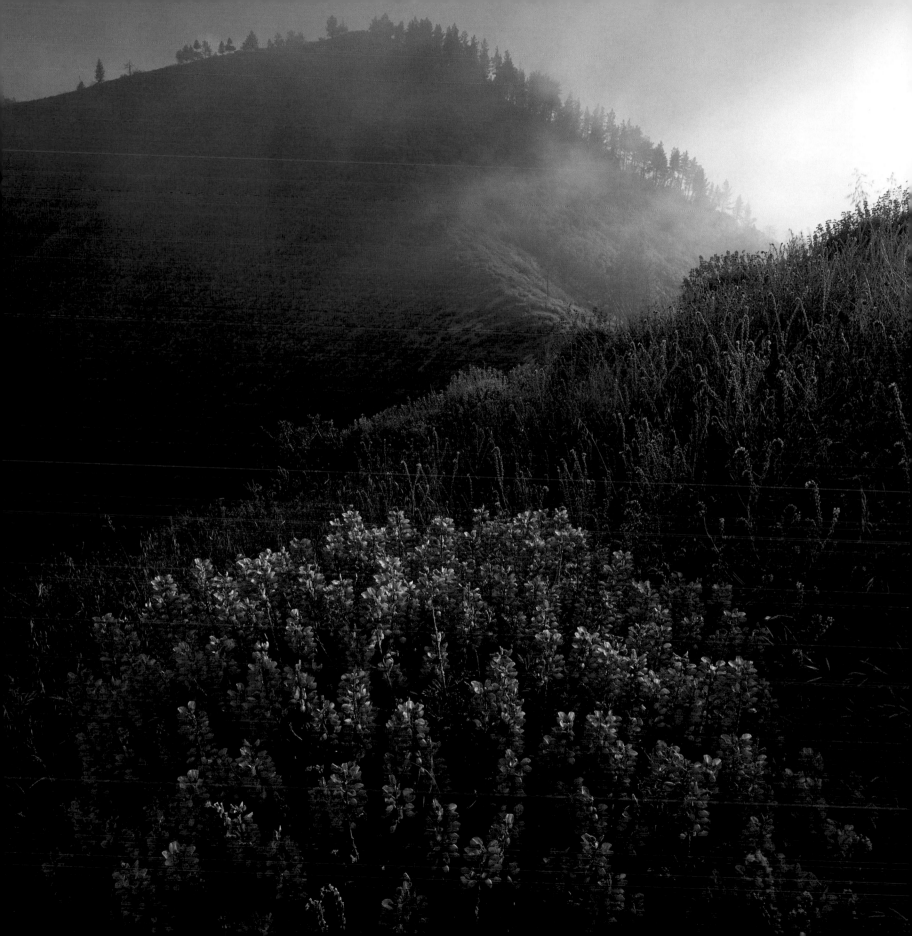

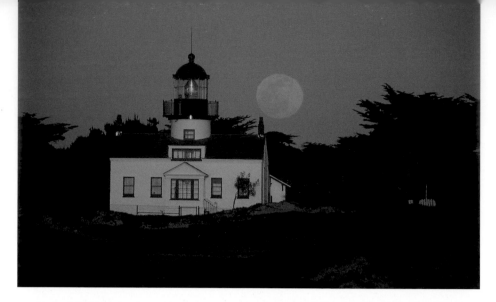

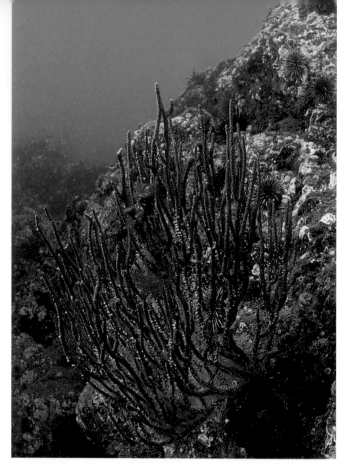

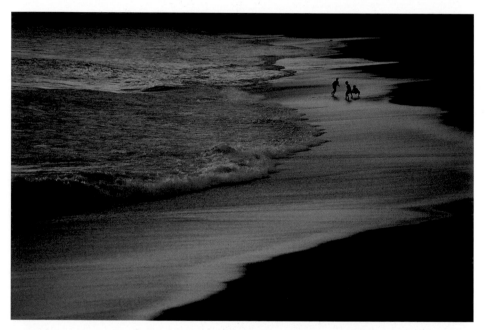

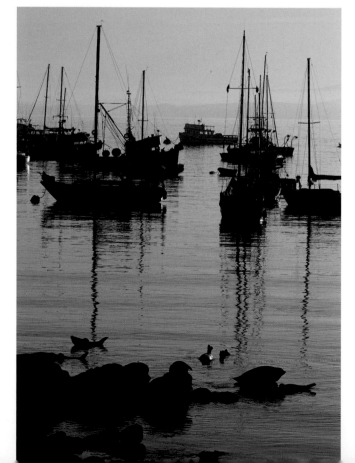

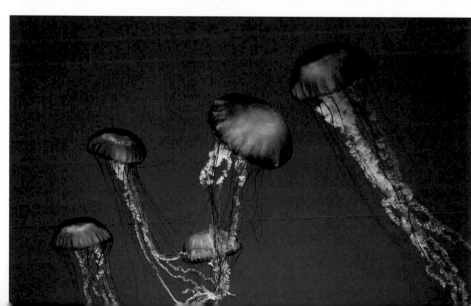

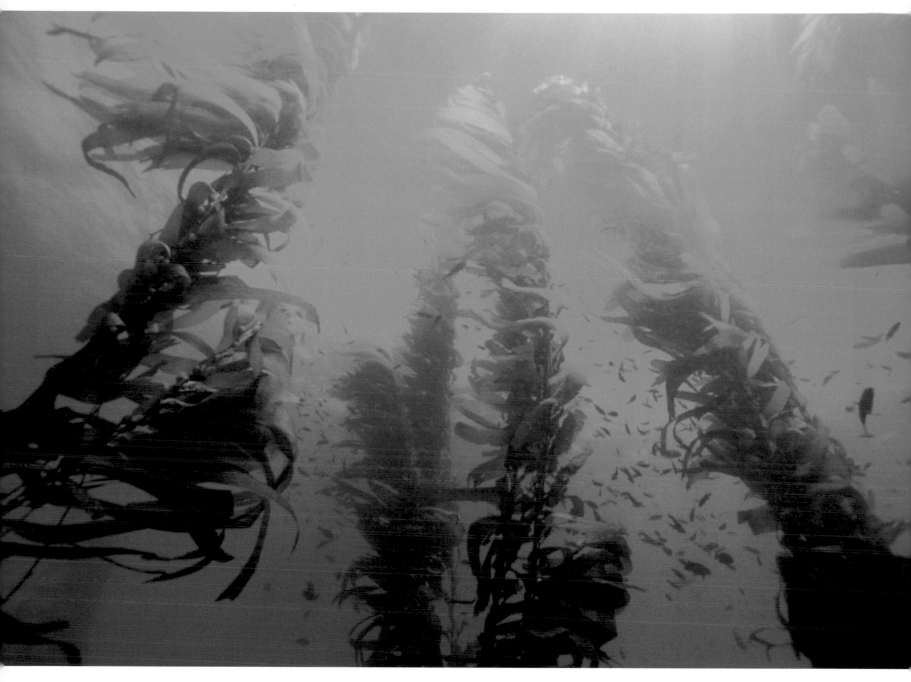

◄ CLOCKWISE FROM TOP LEFT: ● Point Pinos Lighthouse, built in 1855, is the oldest active lighthouse on the West Coast.
● Soft coral, sea urchins, and sea slugs share the rocky bottoms along Anacapa Island.
● Seals in the Monterey Harbor catch the morning sun rays.
● Orange sea nettles swim at the Monterey Bay Aquarium.
● Children play along the surf at Golden Gate National Recreation Area.
▲ Kelp reaches to the surface from sixty feet below in Channel Islands National Park.

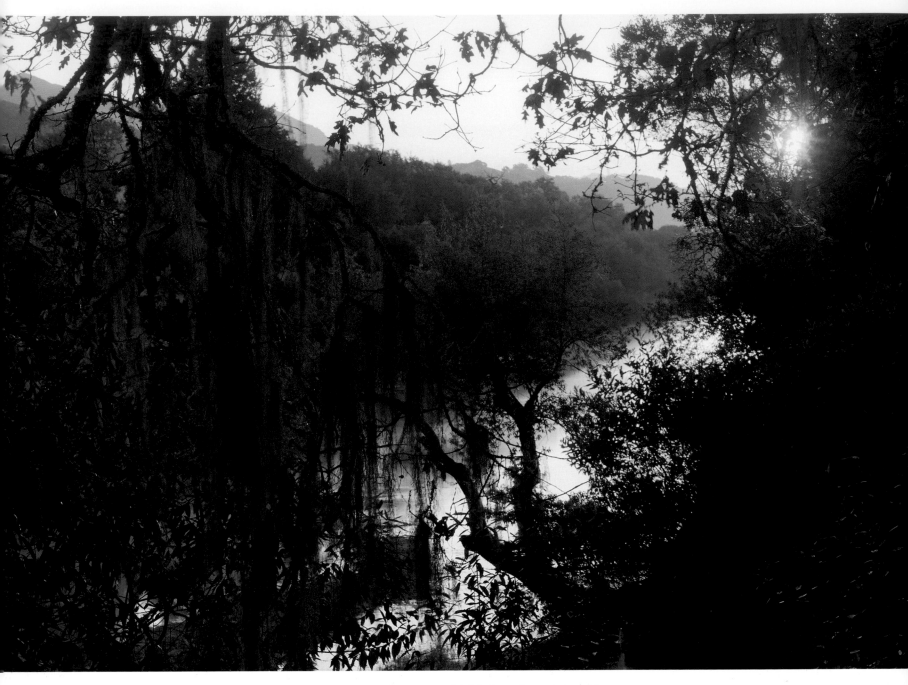

▲ An October sunrise highlights oaks and Spanish
moss along the Russian River in the Alexander Valley, one of six
wine-growing regions in Sonoma County.

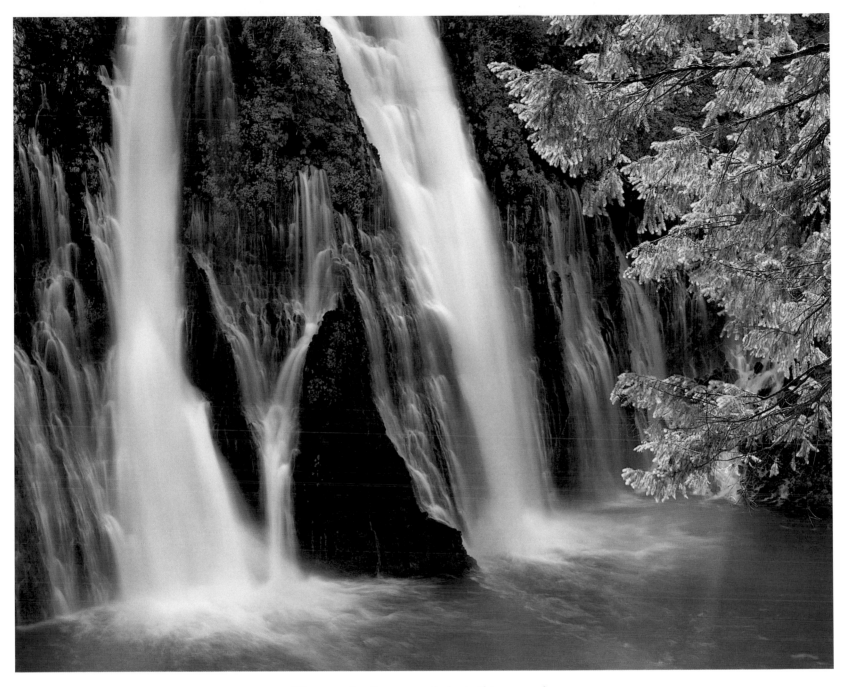

▲ Water seeping from many holes in this porous lava,
laden with ferns, creates a verdant weeping wall,
McArthur-Burney Falls Memorial State Park.

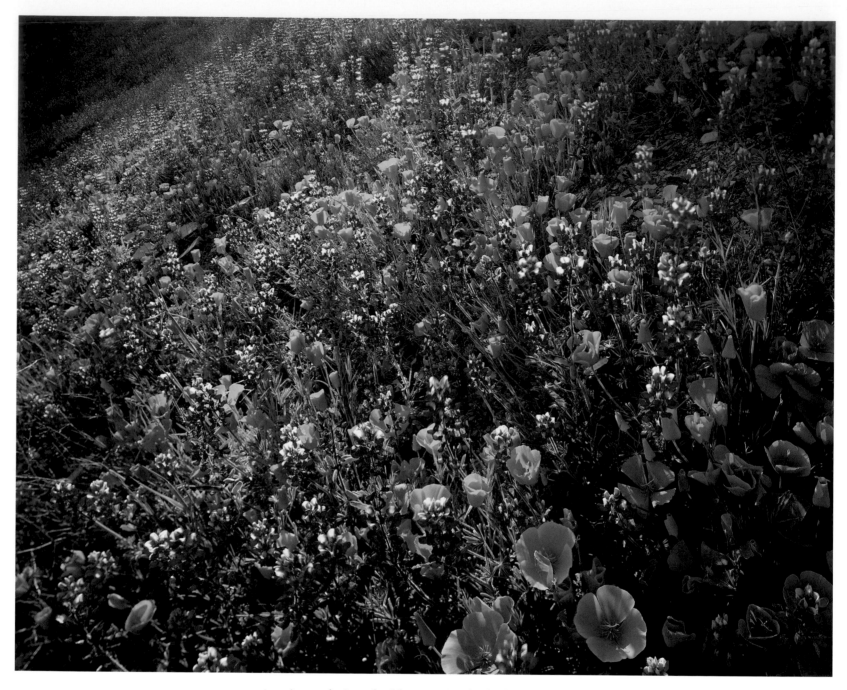

▲ A spring explosion of golden poppies *(Eschscholzia californica),*
the state flower, shares a hillside with lupine in the Los Padres National Forest.
▶ A carpet of goldfields *(Lasthenia chrysostoma)* highlights a ridgeline of
blue oaks on Figueroa Mountain in Santa Barbara County.
▶▶ Oak trees accent the flowering springtime hills in
Pacheco Pass State Preserve along the Diablo
Range in Santa Clara County.

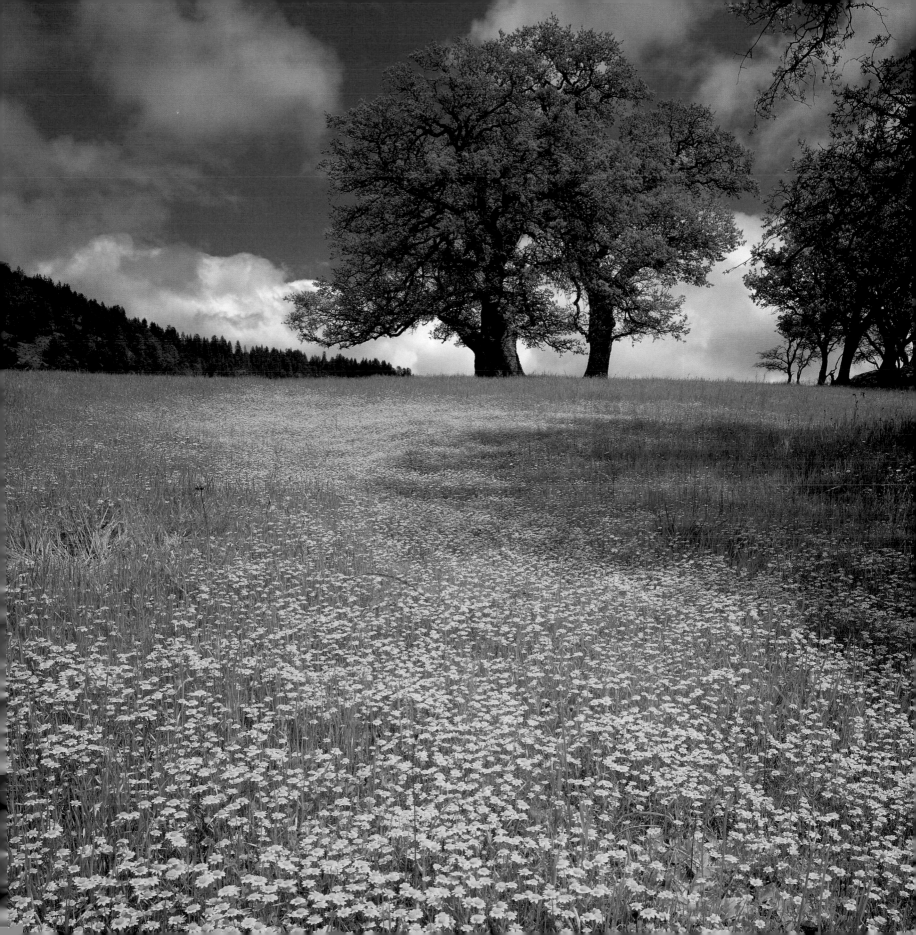

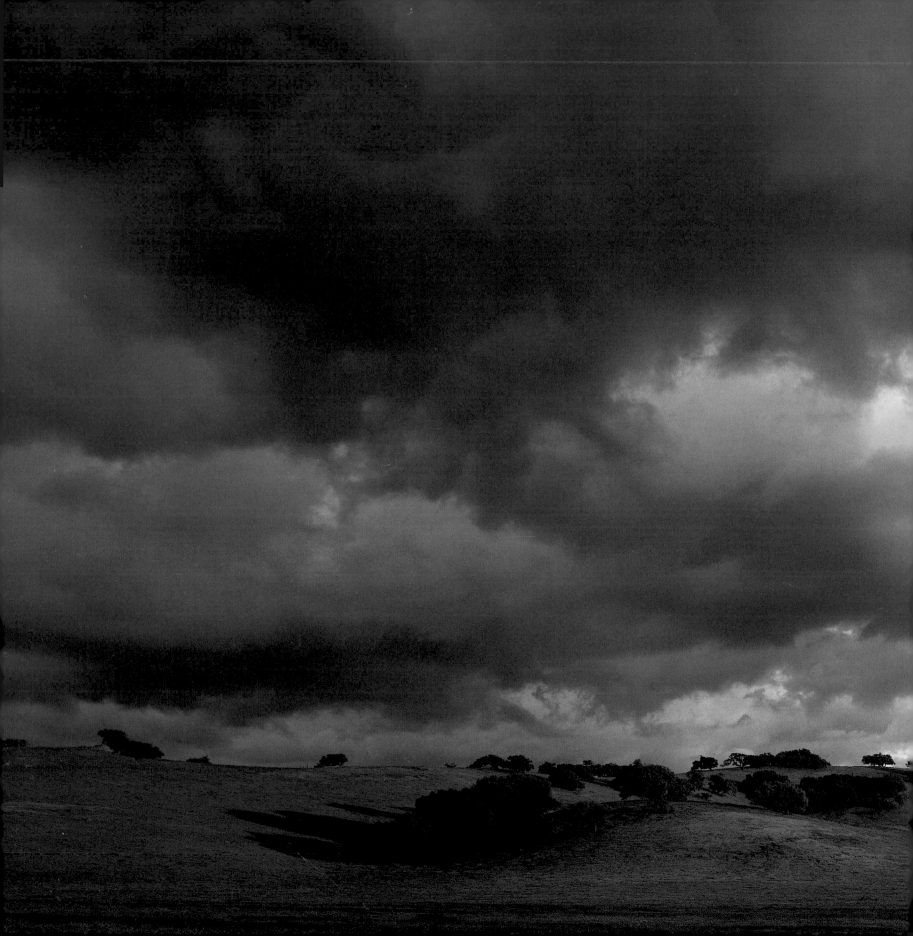

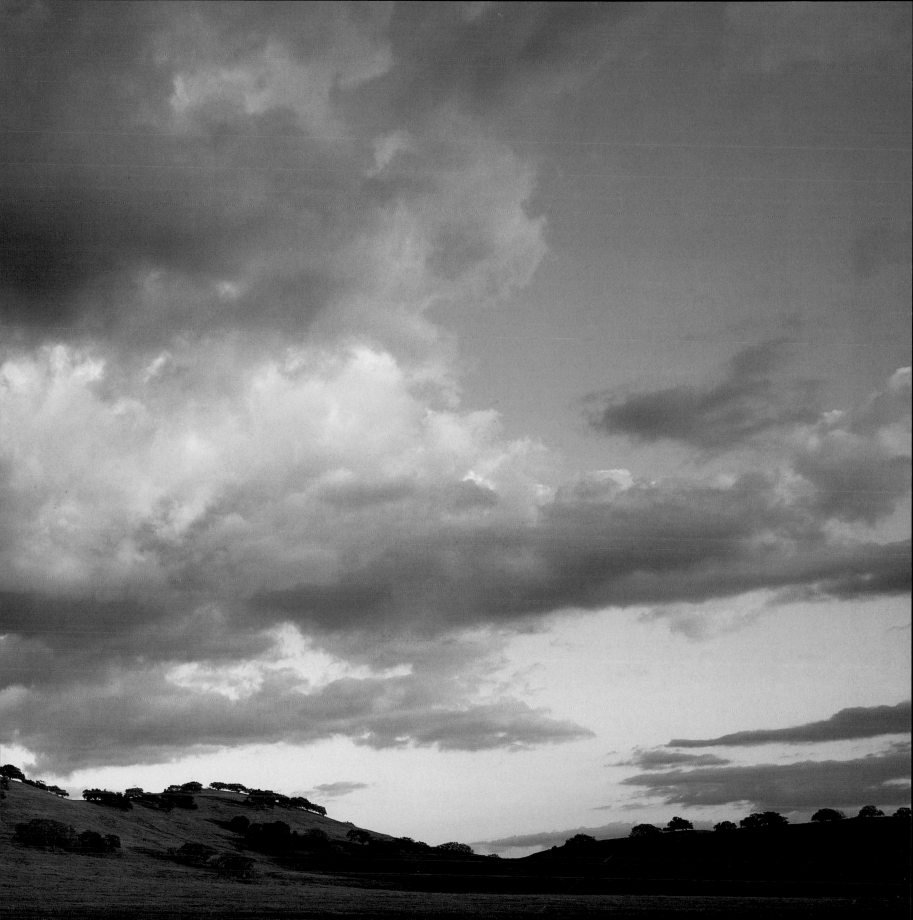

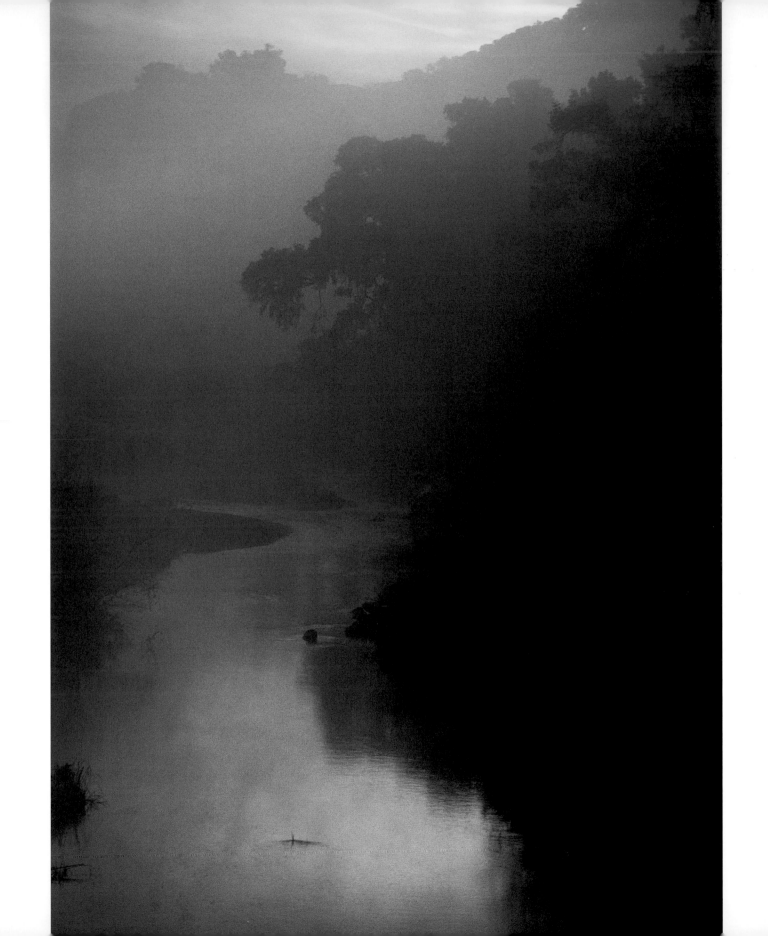

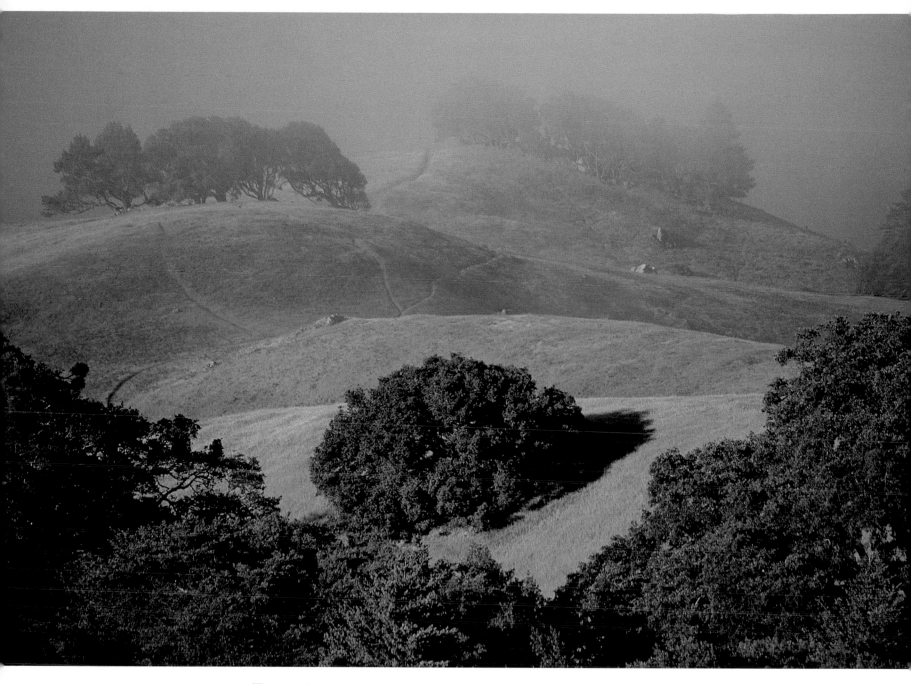

◄ The rosy dawn permeates the foggy shroud of the Santa Ynez River near
the popular Danish-theme tourist town of Solvang, in Santa Barbara County.
▲ Morning fog deepens the rich green grass and oak colors of spring within Mount
Tamalpais State Park. This sixty-three-hundred-acre Marin County park rises
more than twenty-five hundred feet above North San Francisco Bay.

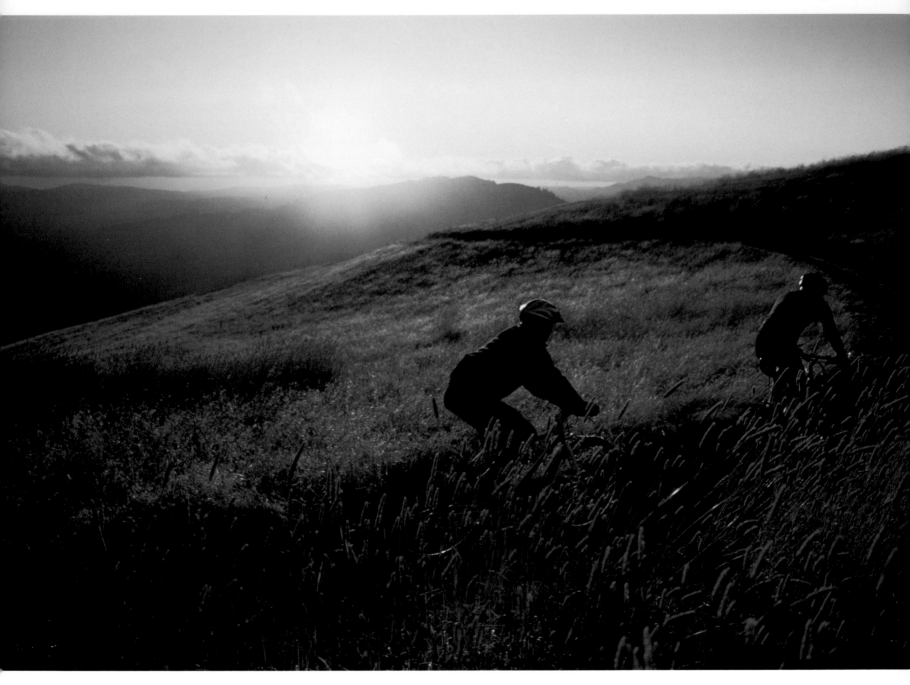

▲ San Francisco Bay Area mountain bikers enjoy the afternoon
ambience along the Open Space Preserve that divides
the coast from the southern part of the bay.

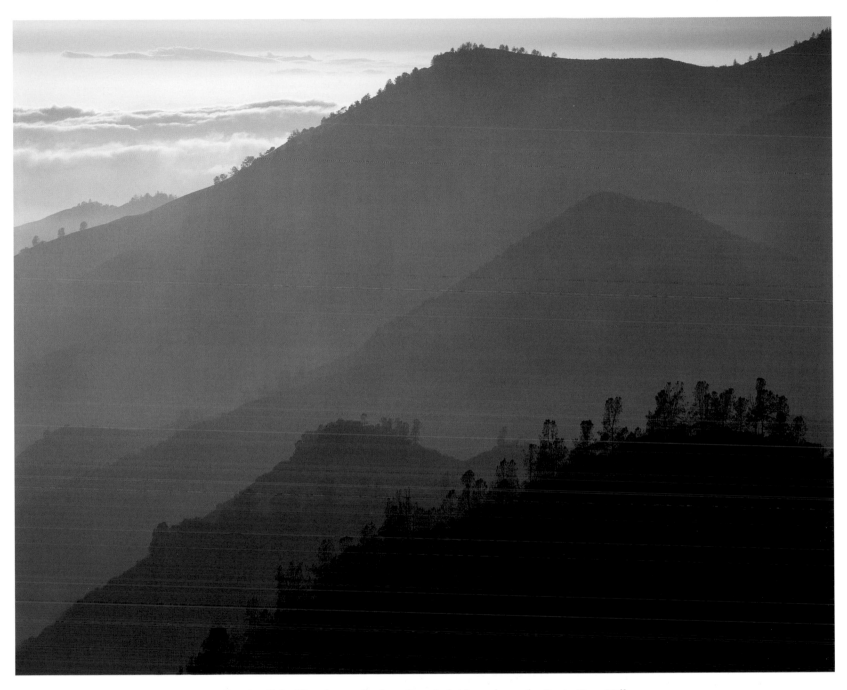

▲ Evening light illuminates the fog-shrouded ridges above the Santa Ynez Valley.
Located in Santa Barbara County, the Santa Ynez Valley has made
a name for itself as California's other wine country.

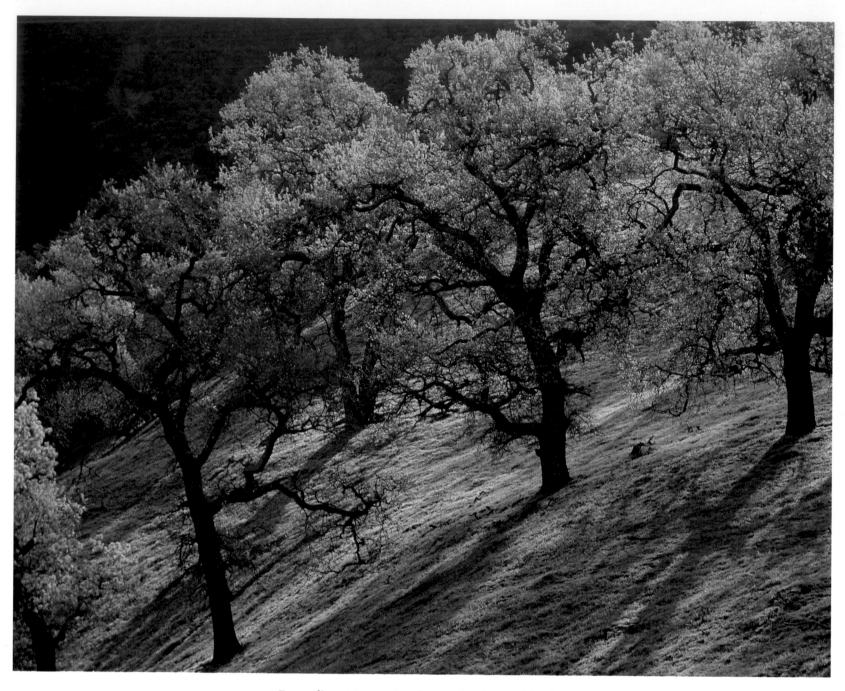

▲ Even adjacent to Los Angeles, on the slopes of the Santa
Monica Mountains, oaks grace the land with an eternal pastoral beauty.
▶ A spring riot of inland blue larkspur *(Delphinium patens)* and owl's clover
(Orthocarpus purpuracens) dominates the wildflower mix around
Soda Lake, Carrizo Plain, San Luis Obispo County.

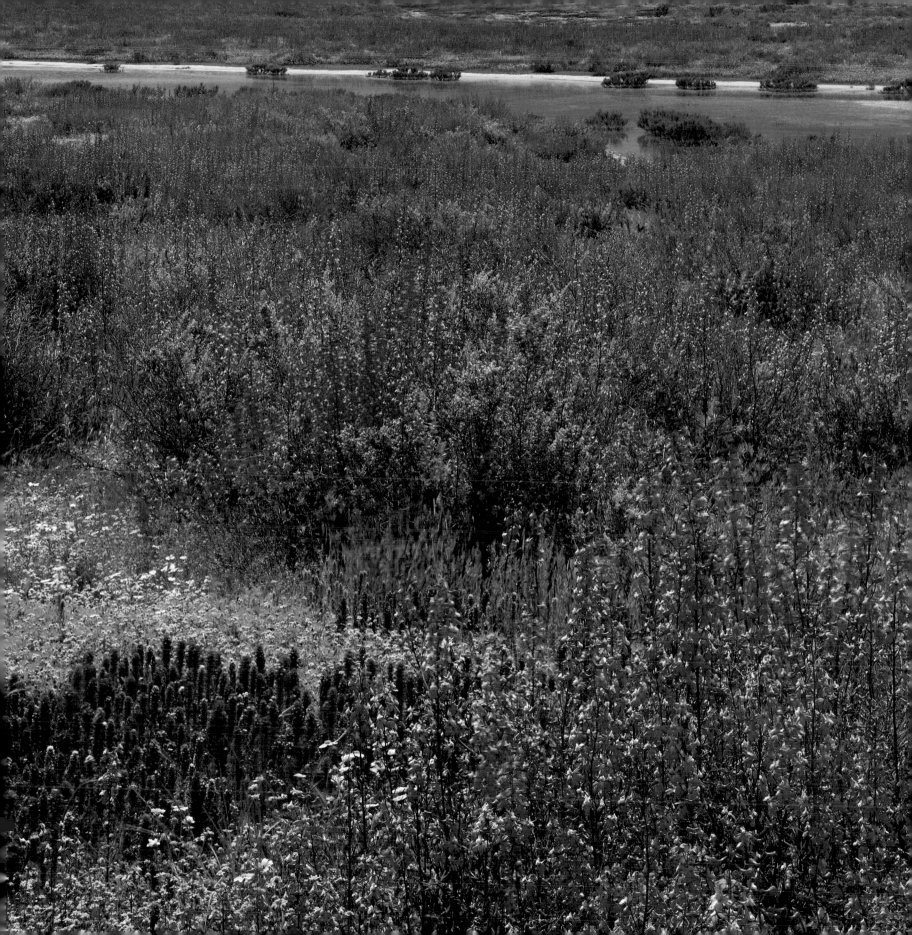

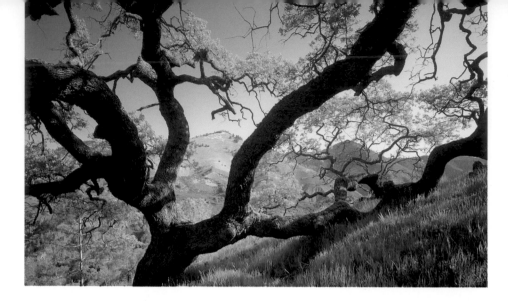

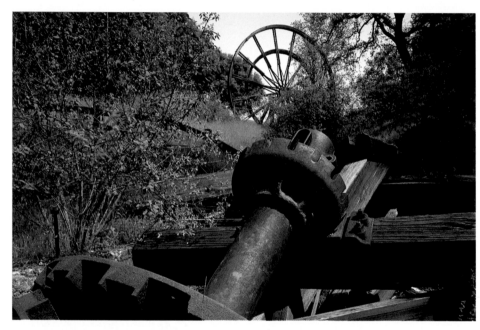

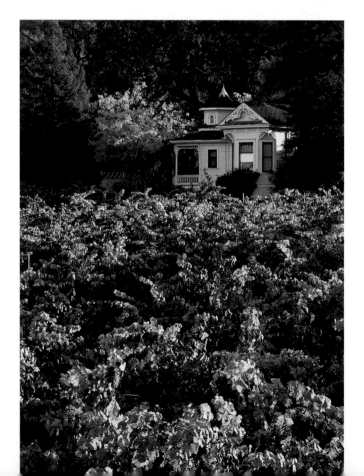

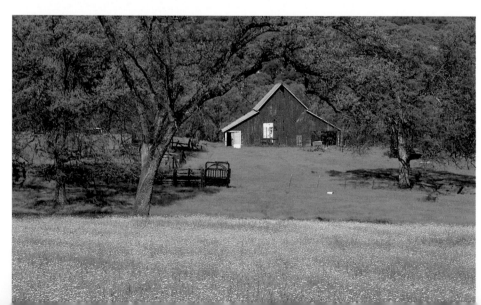

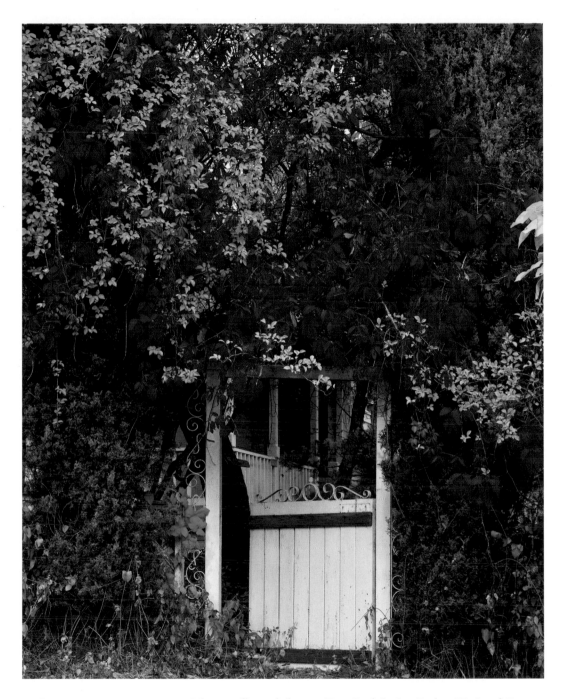

◄ CLOCKWISE FROM TOP LEFT: ● A large valley oak frames Zaca Peak in Los Padres National Forest.
● Two young explorers see how it was during Gold Rush days in Coloma, near Sutter's Mill.
● Nestled in October shade, a Napa County vineyard includes a house for wine tasting.
● A working barn anchors this country view in Mariposa County, Mother Lode Country.
● A mining stamp mill relic and tailing wheel recall Gold Fever in the Mother Lode.
▲ Turning leaves frame the entrance to a historic home in Coloma, home of Marshall
Gold Discovery State Historical Park, along the South Fork of the American River.

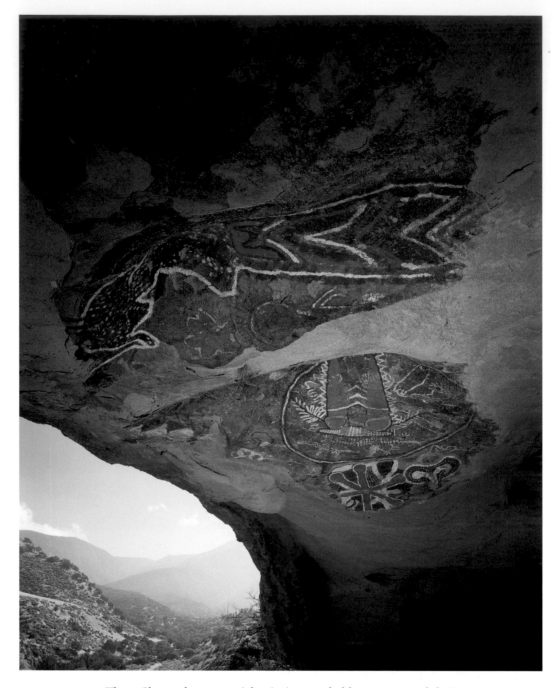

▲ These Chumash ceremonial paintings probably were created during
the Mission Period (1769–1834). This San Emigdio Painted Cave
is in the Chumash Wilderness of Los Padres National Forest.

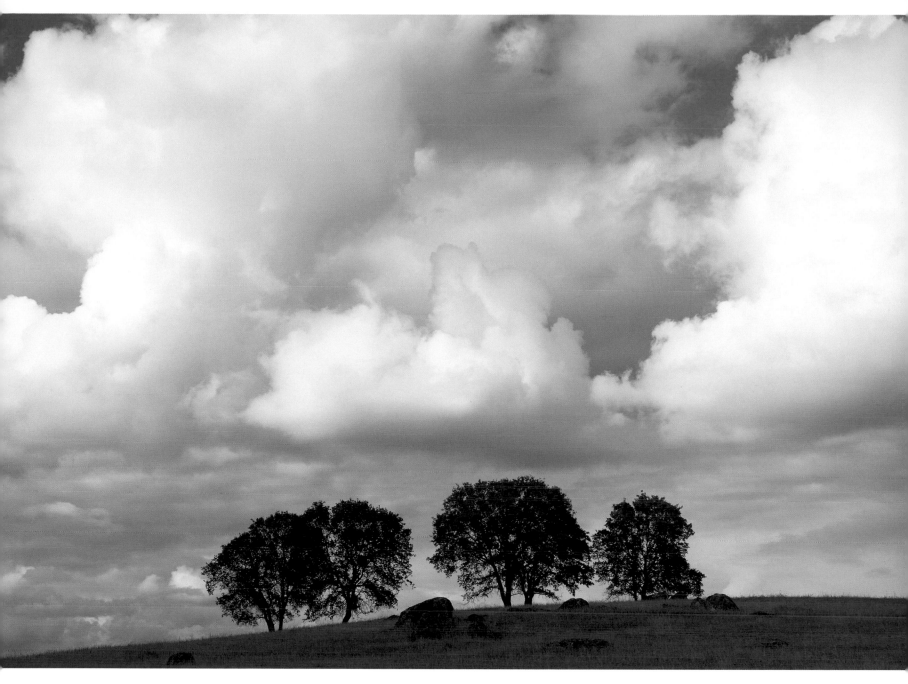

▲ Blue oaks knit a spring cumulus sky to the green velvet pasture
lands of Tuolumne County near Sonora, Sierra
foothill country west of Yosemite.

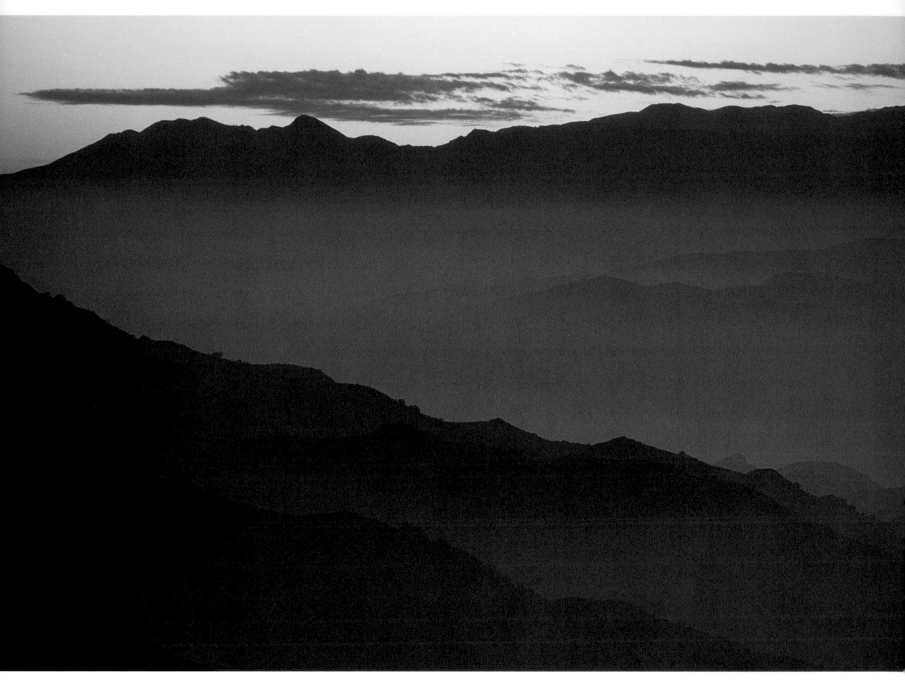

▲ Marine haze, carried into the Fillmore Valley by onshore winds,
turns sunset light into alluring pastels, cupped by
the coastal Sierra Madre Mountains.

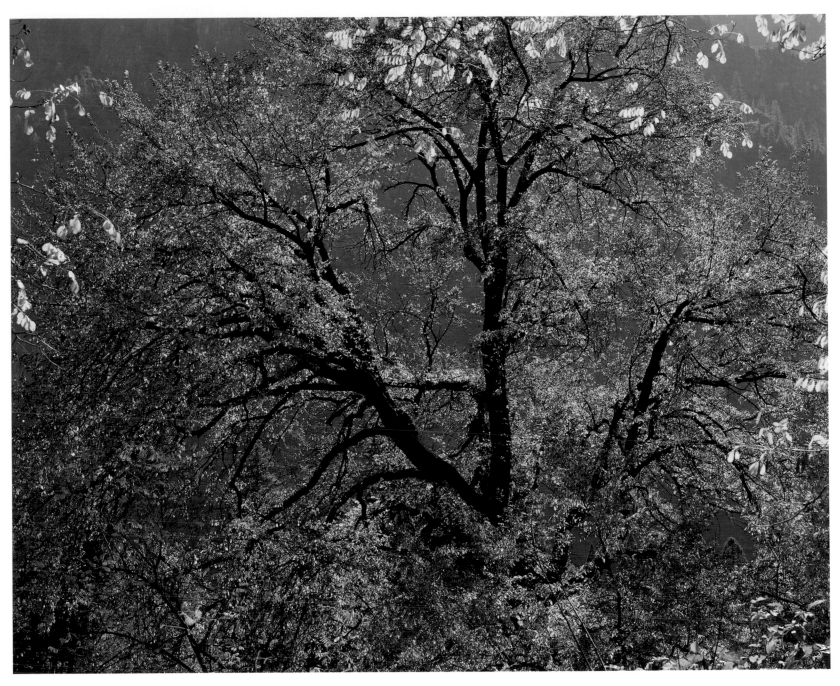

▲ The graceful branches of a black oak *(Quercus velutina)*
are illuminated by fall colors in Yosemite Valley.

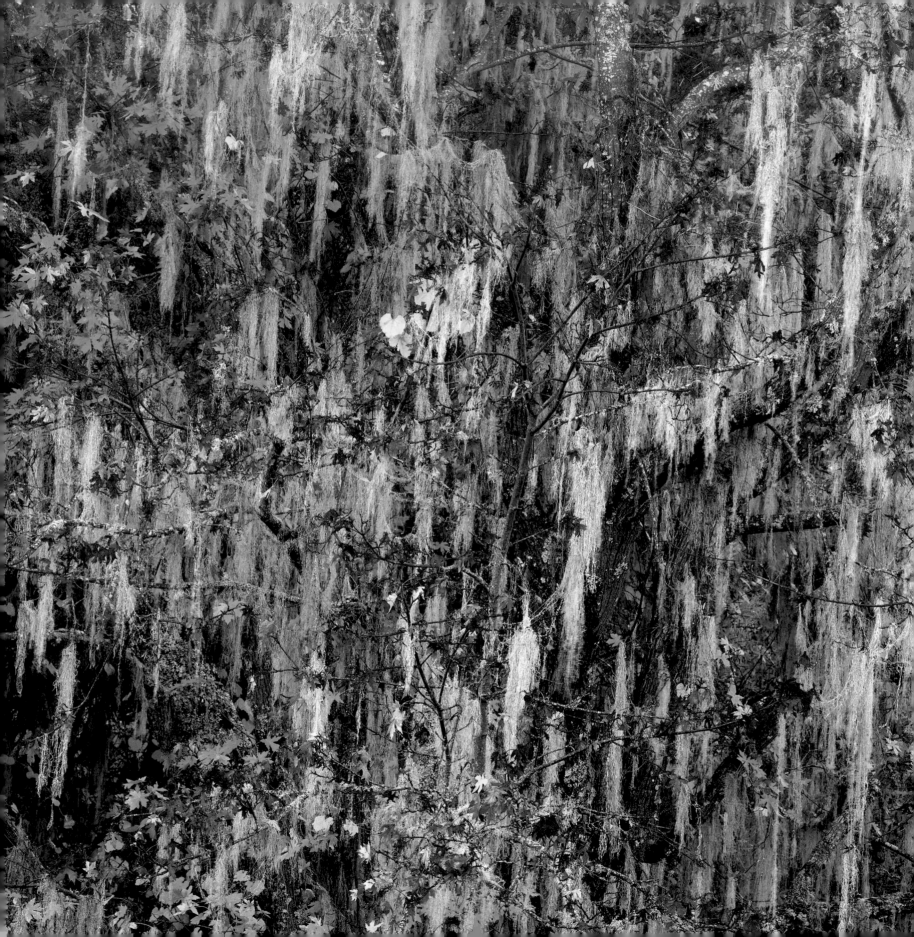

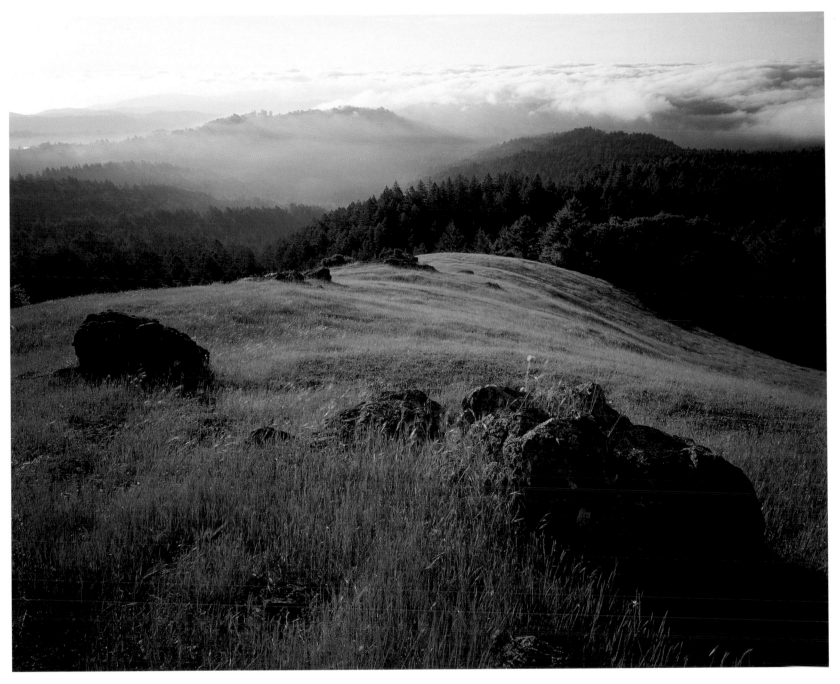

◄ Autumn maple and oak branches host an intricate design
of Spanish moss *(Tillandsia usneoides)* in Capell Valley, Napa County.
▲ This inviting view south toward San Francisco is seen
from Mount Tamalpais State Park.

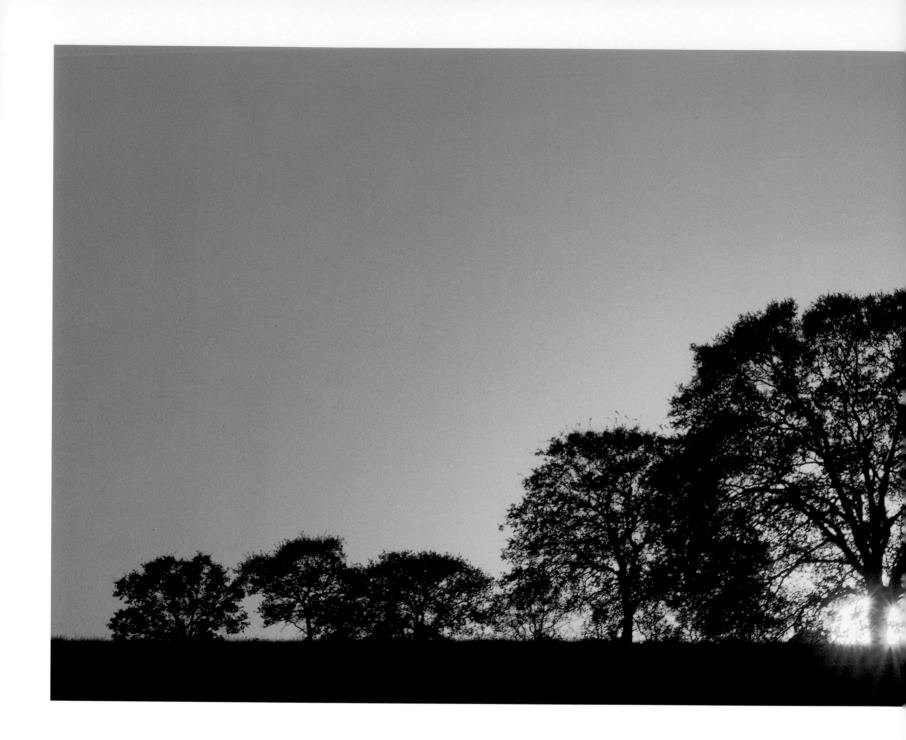

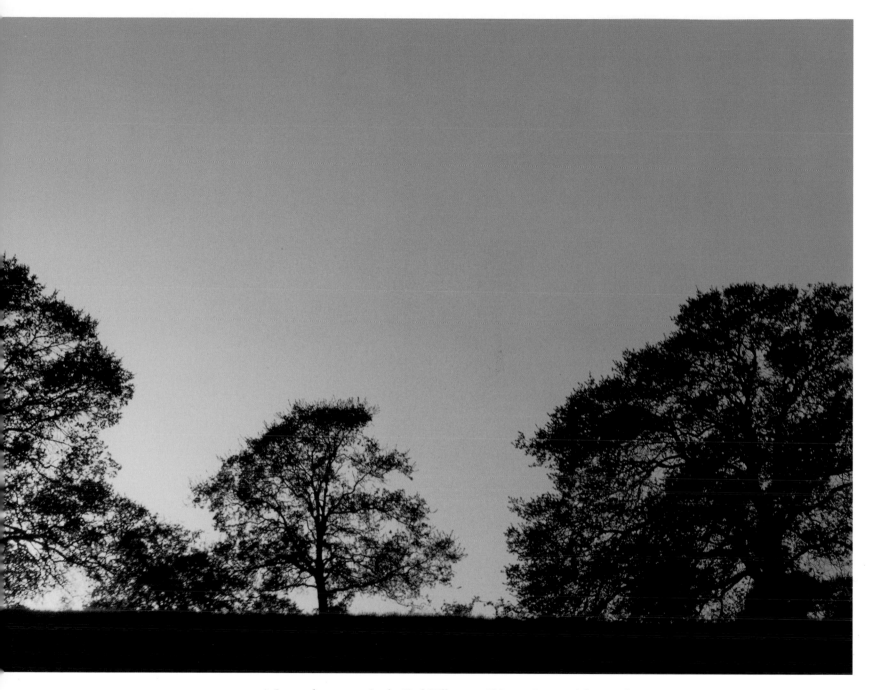

▲ A September sunset in the Red Hills near Chinese Camp celebrates the
full-canopied magnificence of oaks. This stretch near the Stanislaus
River in the Western Sierra Mother Lode Country is typical
of California's oak-blessed hills and valleys.

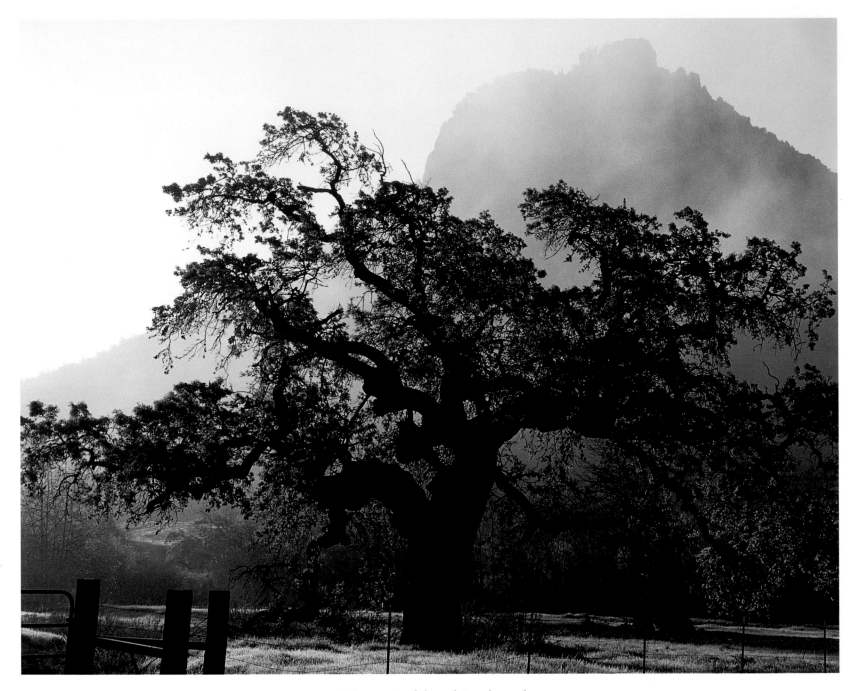

▲ The magic of the oak is enhanced
by morning fog along Pacheco Creek, Diablo Range.
▶ Indian rhubarb *(Darmera peltata)* graces whispering waters along
the Silver Fork of the American River, El Dorado County.

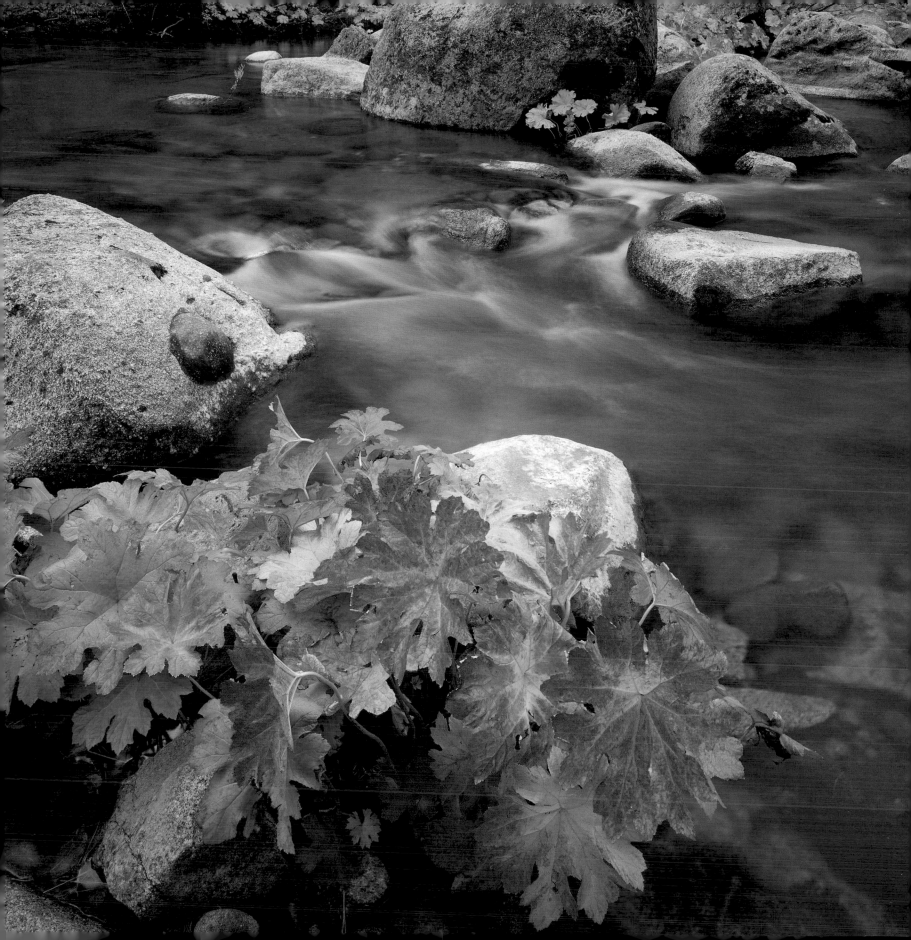

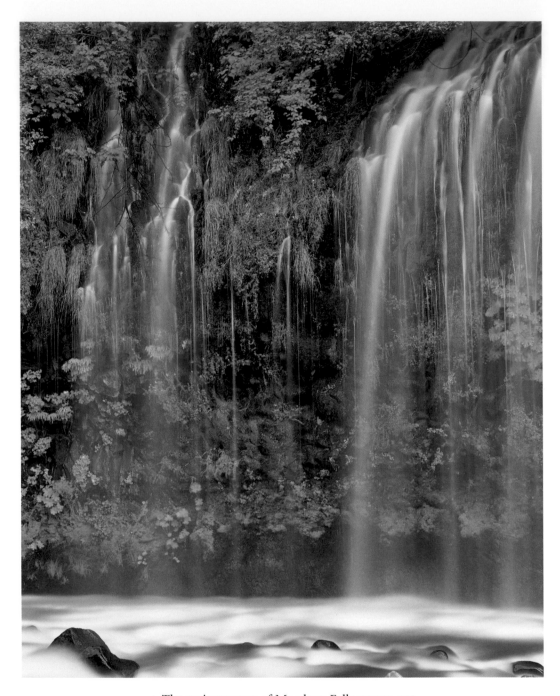

▲ The spring waters of Mossbrae Falls stream out
of porous volcanic rock along the upper Sacramento River,
which flows by on its southerly journey to the Sacramento Delta Region.
► An October sunrise warms a mix of oak and Spanish moss
along the Russian River in Alexander Valley.

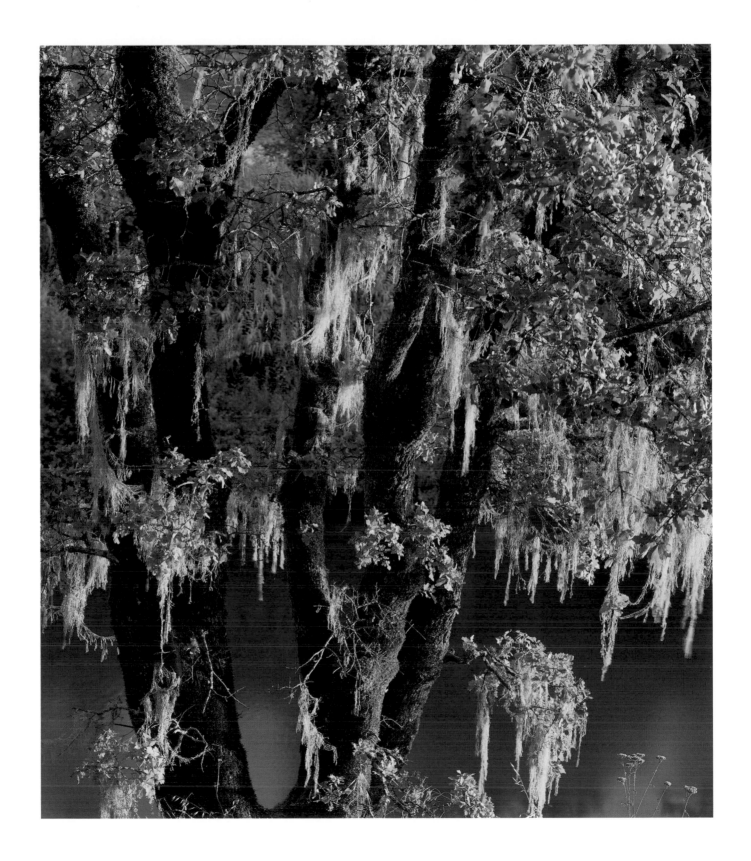

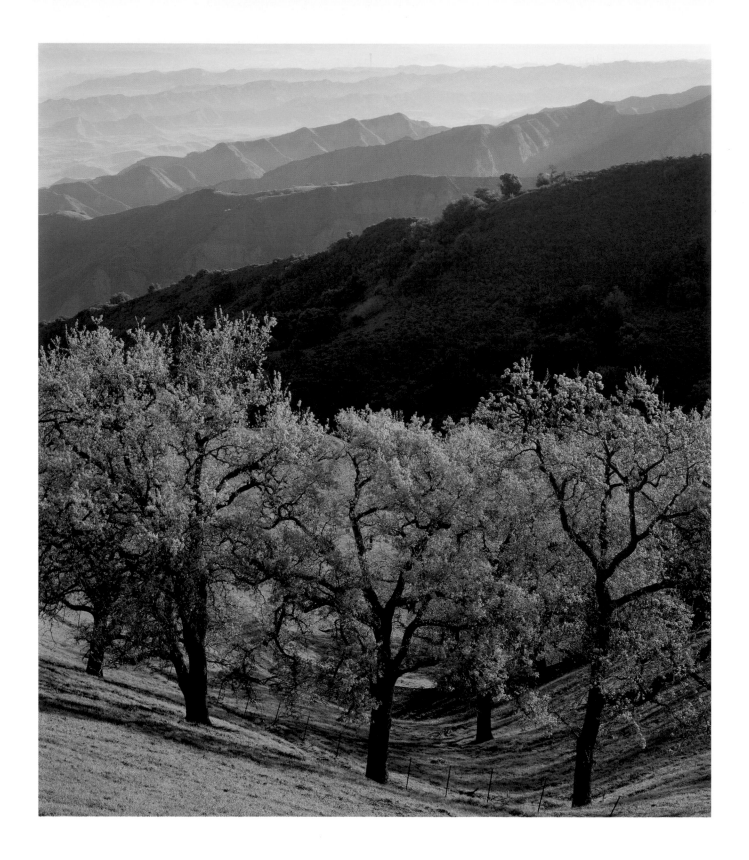

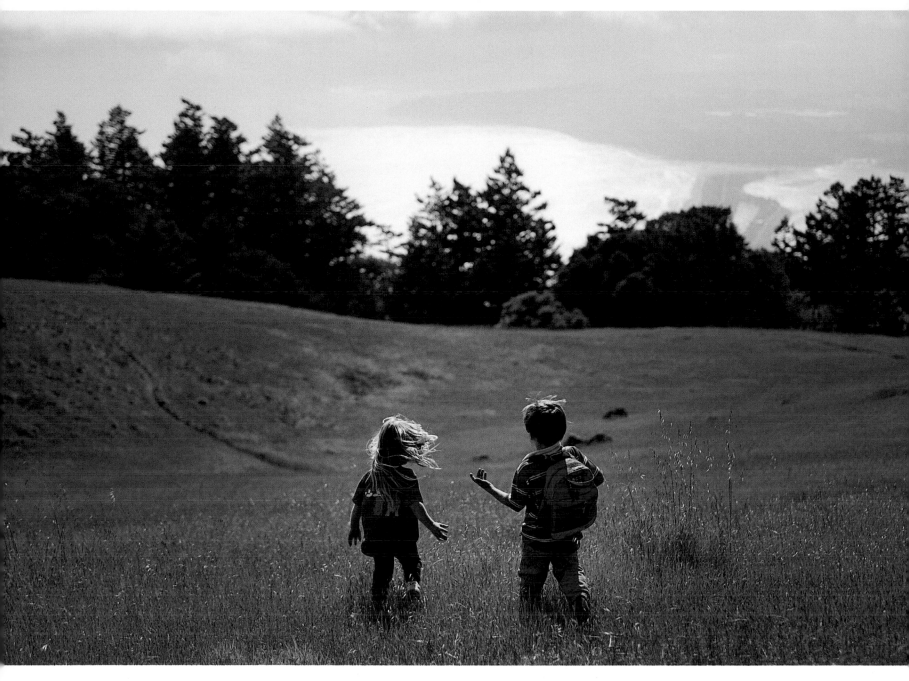

◀ Oak-rich slopes of the Sierra Madre Mountains spill across
this southern panorama that looks into the distant Los Angeles Basin.
▲ Childhood memories flourish in the grassy meadows
of Mount Tamalpais State Park.

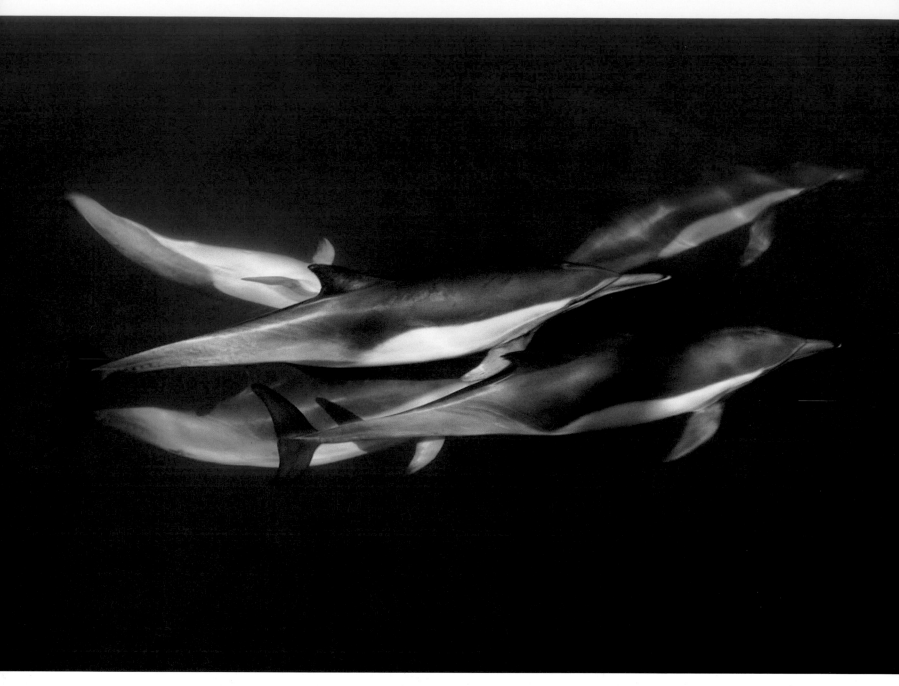

▲ Bottlenose dolphins *(Tursiops truncatus)* cavort in the clear waters of Channel Islands National Park, off the Santa Barbara coast.

► Clockwise from top left: ● A monument recalls the 1542 landing of Juan Rodriguez Cabrillo at San Diego Bay.

● A family gathers at the La Jolla Beach shore for a last glimpse of the setting Pacific sun.

● Species *Homo sapiens* (kid size) goes eye to eye with *Ursus maritimus* at the San Diego Zoo.

● Built in 1891, this skeletal tower replaced San Diego's original Point Loma Lighthouse, built in 1854.

● A trainer at San Diego's Sea World gets a free ride from Shamu, a popular killer whale *(Orcinus orca)* performer.

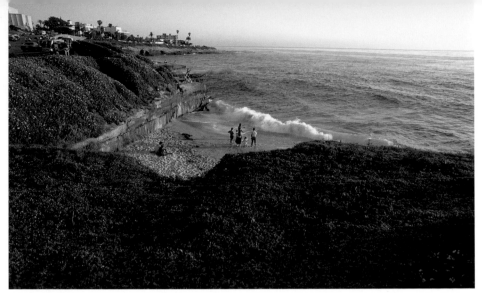
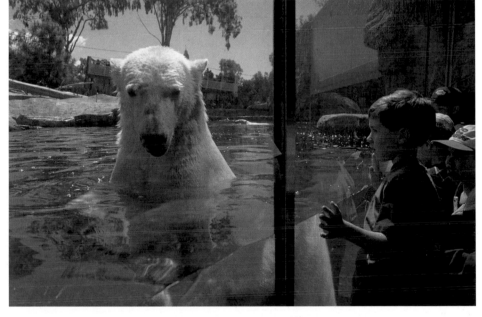
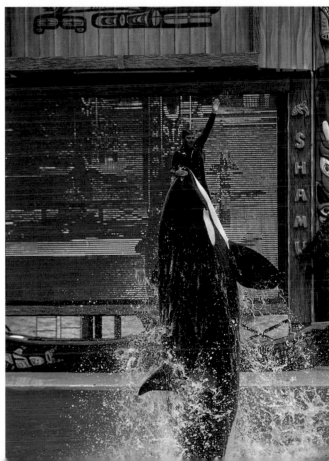
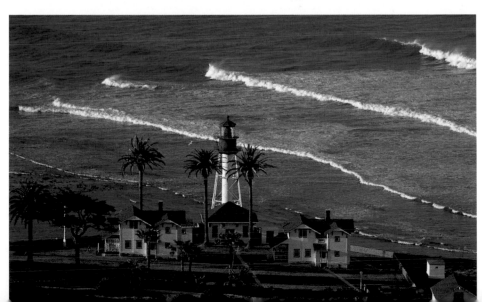

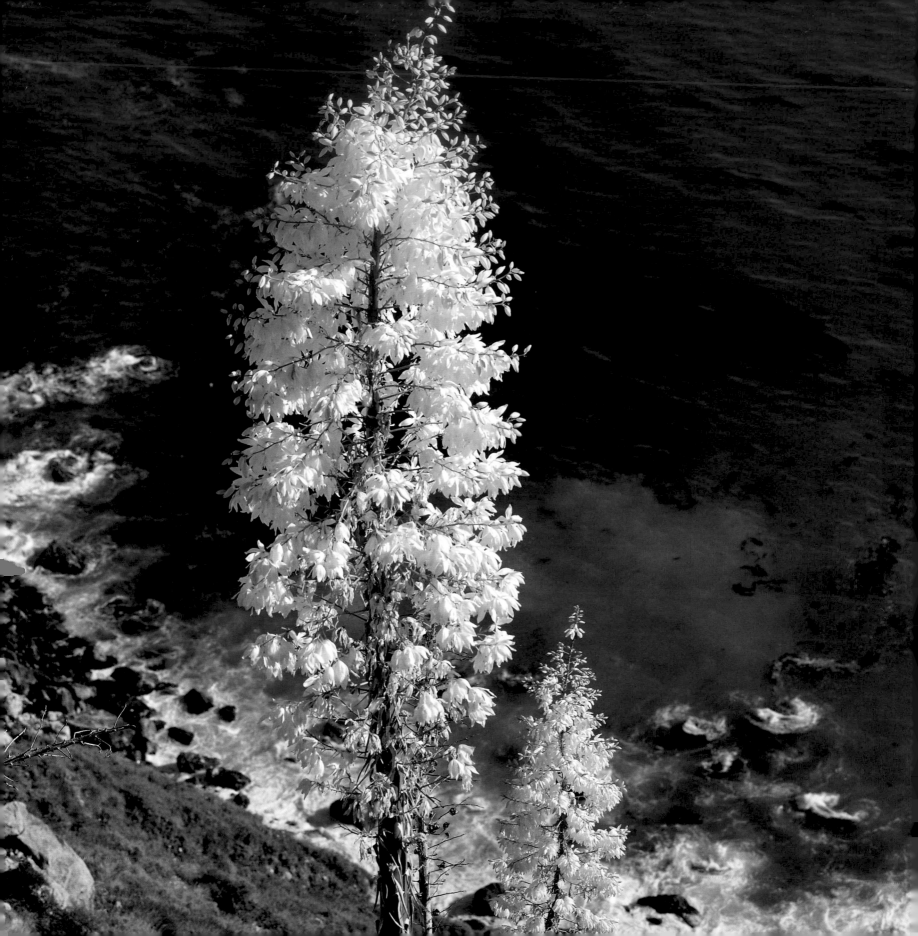

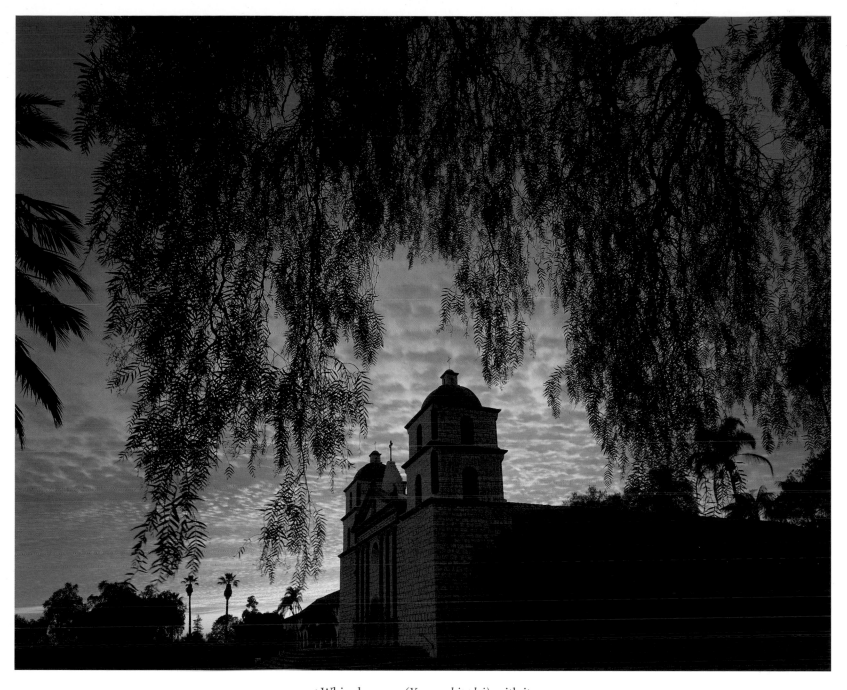

◄ Whipple yucca *(Yucca whipplei),* with its
ten-foot stalks and bell-shaped blossoms, adds a
warm contrast to the blue Pacific, along the Big Sur coast.
▲ Beneath a benevolent tree canopy and a sheltering sunset sky, Mission
Santa Barbara, built in 1782 but damaged in six major earthquakes
since, stands proudly renovated and operational today.

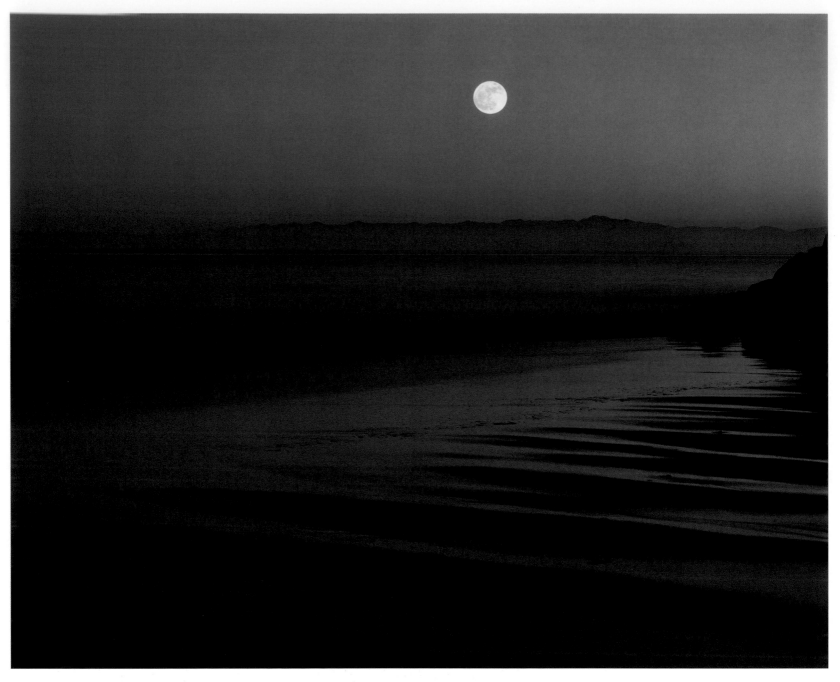

▲ Distant Santa Cruz Island glows in the moonlight above the
fluid Pacific sea of the Santa Barbara coast.

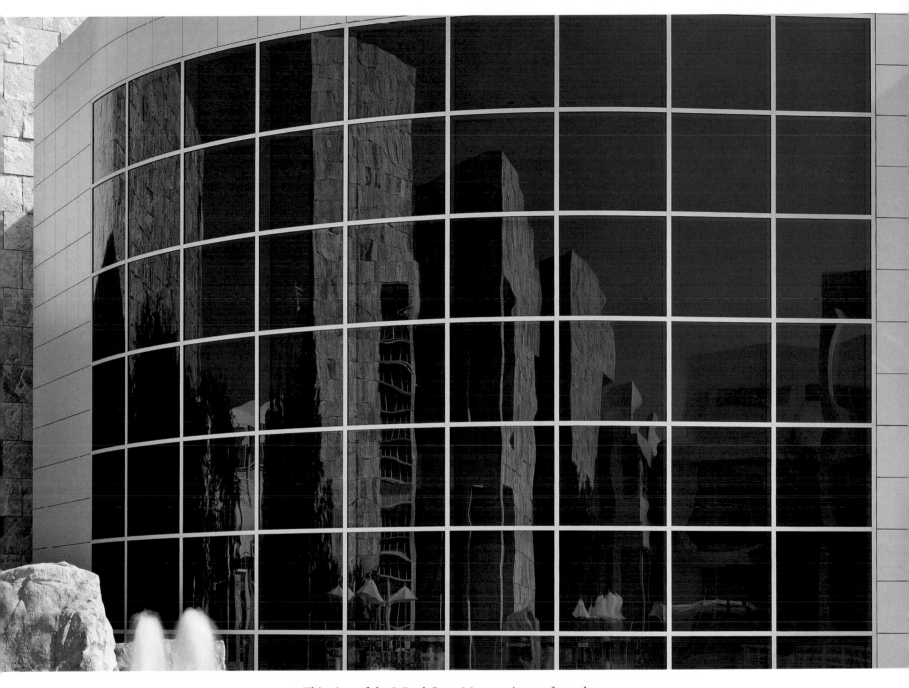

▲ This view of the J. Paul Getty Museum is seen from the
courtyard, at the Getty Center in Los Angeles.

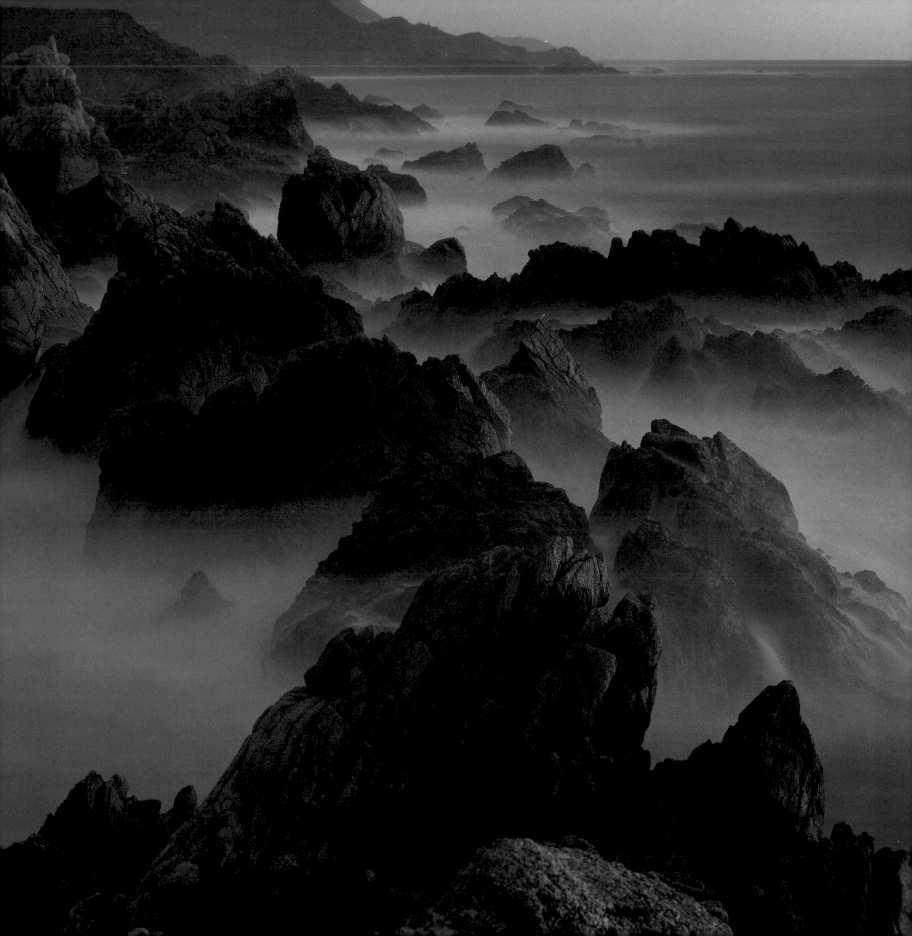

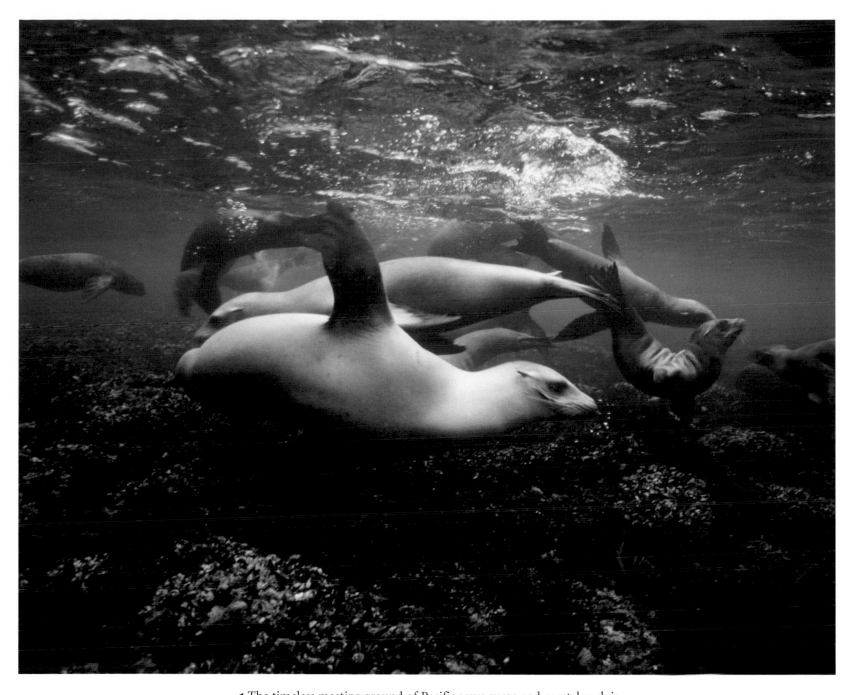

◄ The timeless meeting ground of Pacific wave surge and coastal rock is
captured at sunset along the Big Sur coast headlands of Garrapata State Park.
▲ A baby sea lion *(Zalophus californiana)* gets swimming lessons below the rookery
on the east end of Santa Barbara Island, Channel Islands National Park.

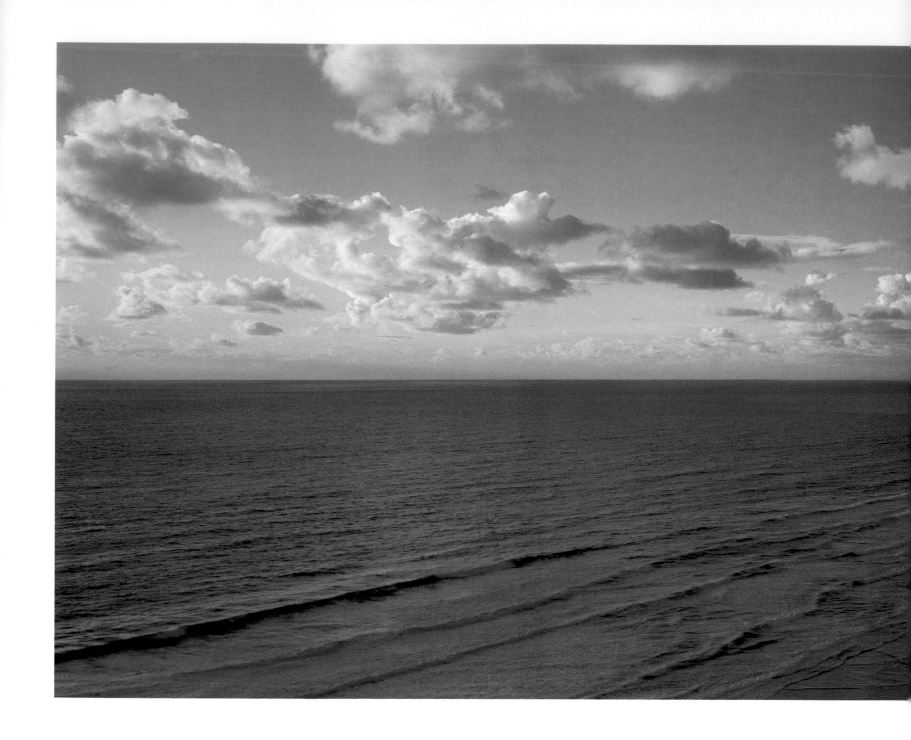

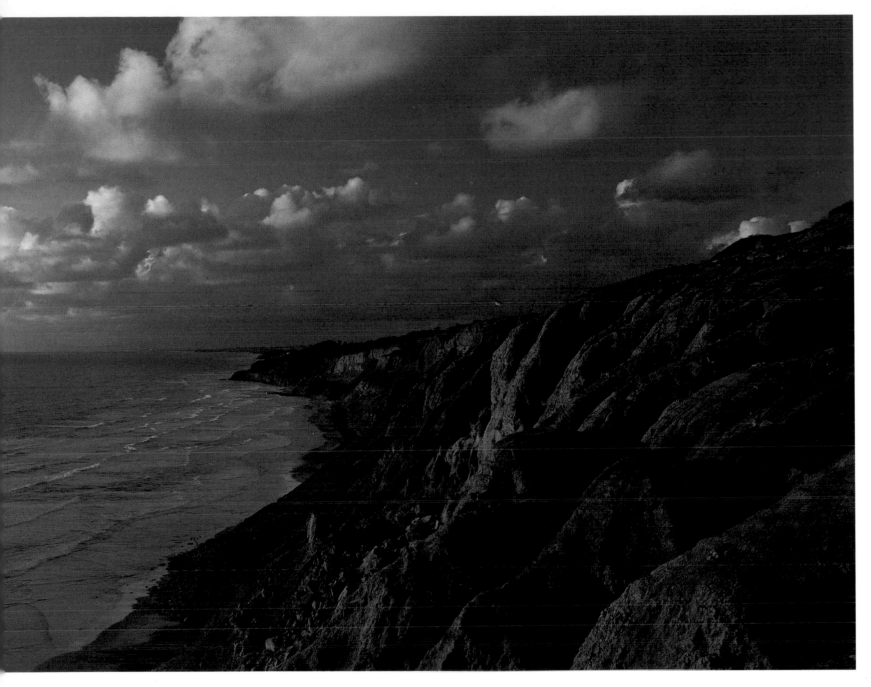

▲ Evening cumulus clouds sail the chilly spring skies along this favorite
San Diego area soaring site, Torrey Pines State Park.

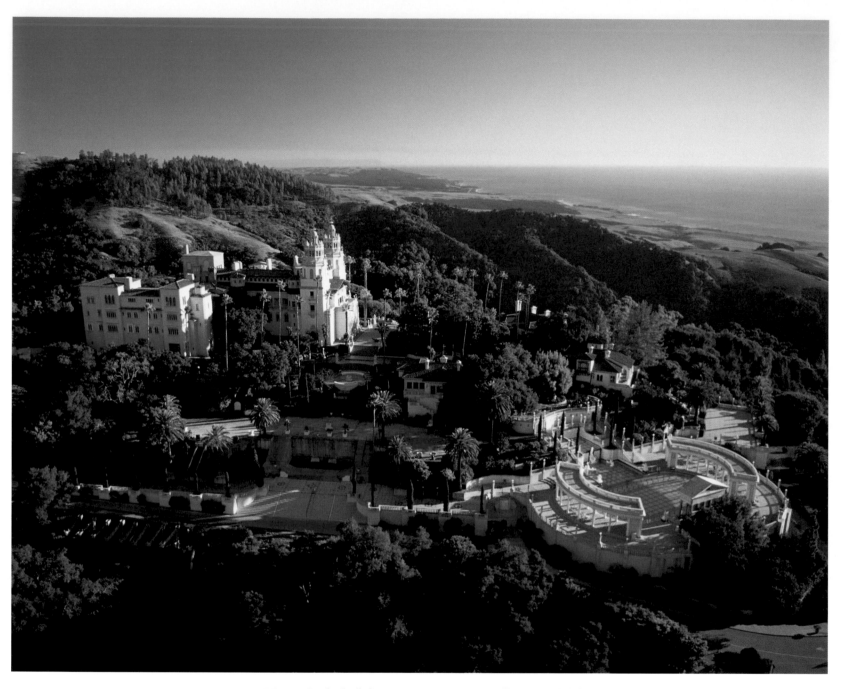

▲ Hearst Castle, built by newspaper tycoon William Randolph
Hearst, is a 127-acre hilltop estate of gardens, terraces, pools, and a
130-room mansion complete with art and antiquities from around the world.
▶ Opened in 1937 and hailed as one of the "Seven Wonders of the Modern
World," the Golden Gate Bridge spans 4,600 feet of San Francisco Bay. Its
suspension towers reach 746 feet, and the sea clearance is 220 feet.

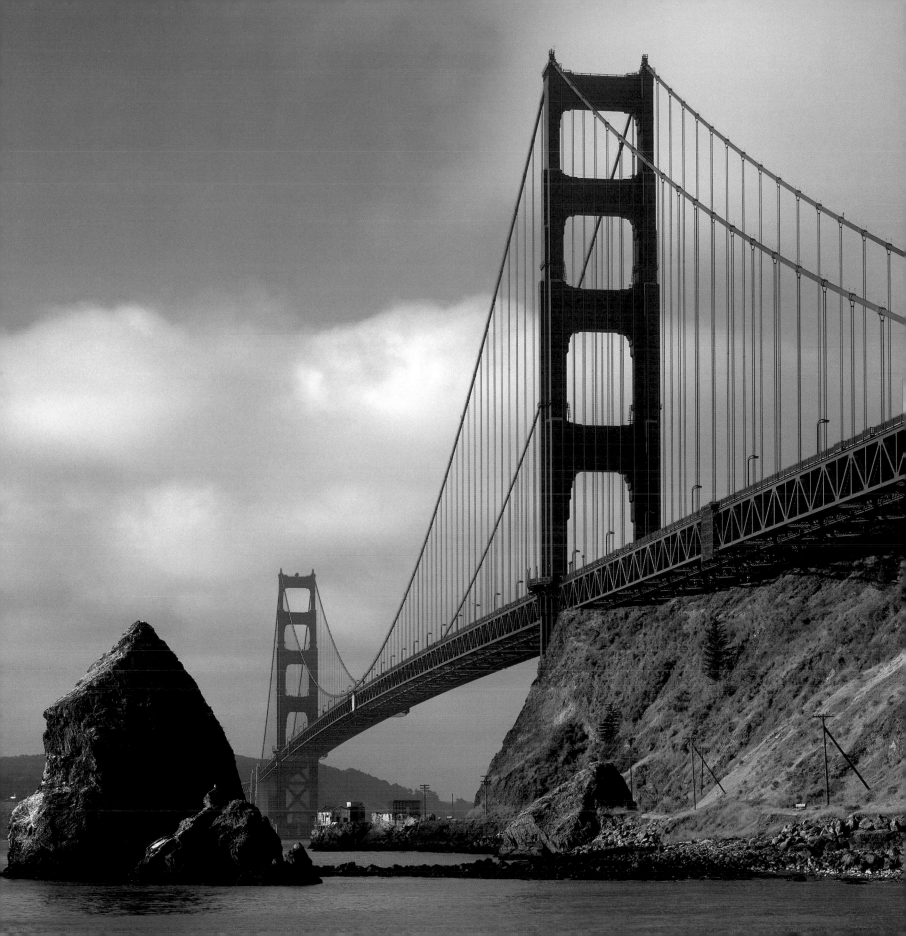

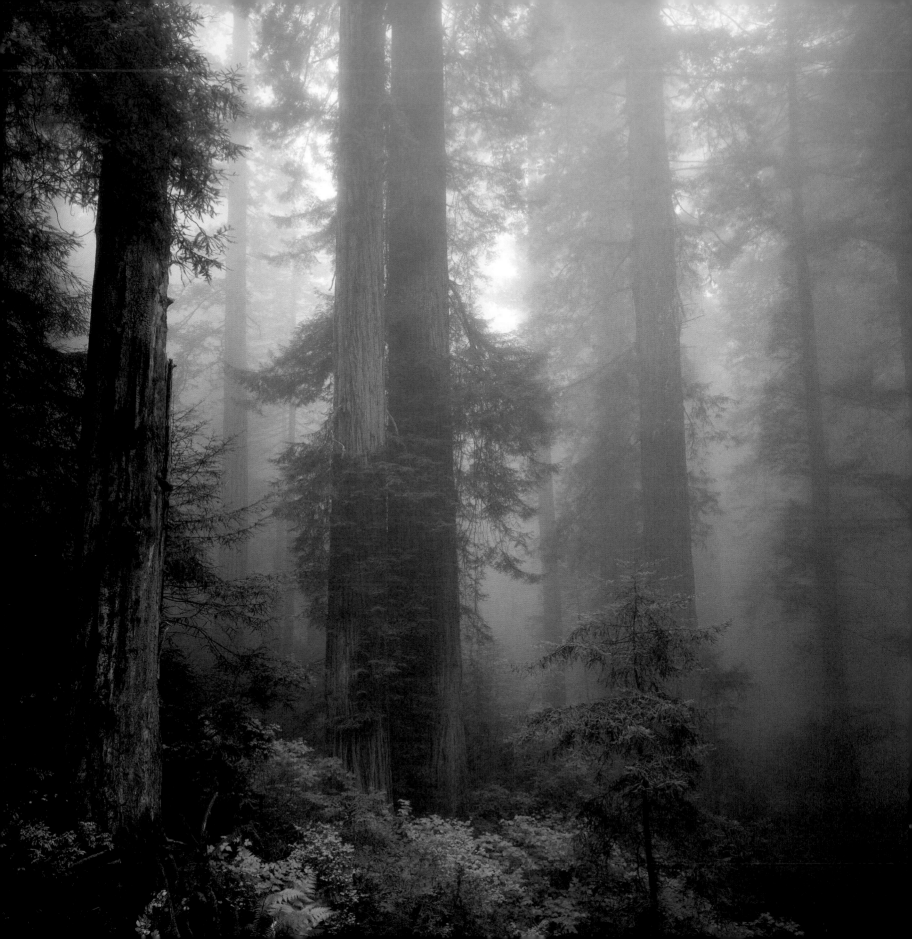

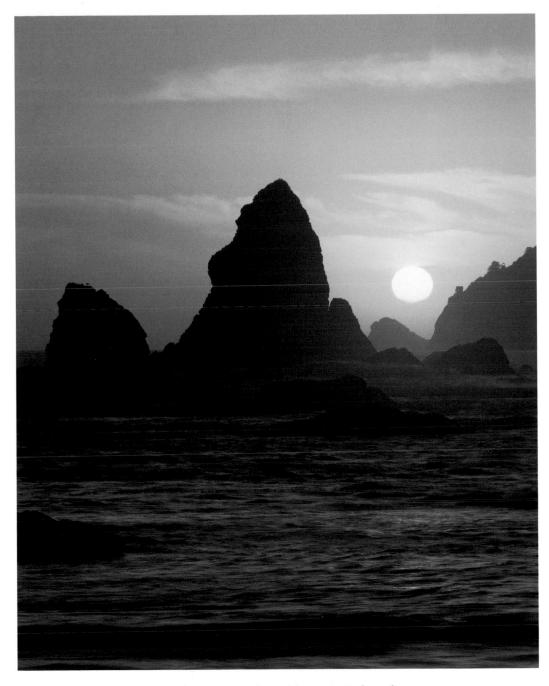

◄ This mature redwood forest, in Redwood
National Park, is nurtured by the morning fog.
▲ A flood of sunset amber light completes the impressionistic
composition of surf, wind, waves, and seastacks along
Trinidad's rugged Moonstone Beach coastline.

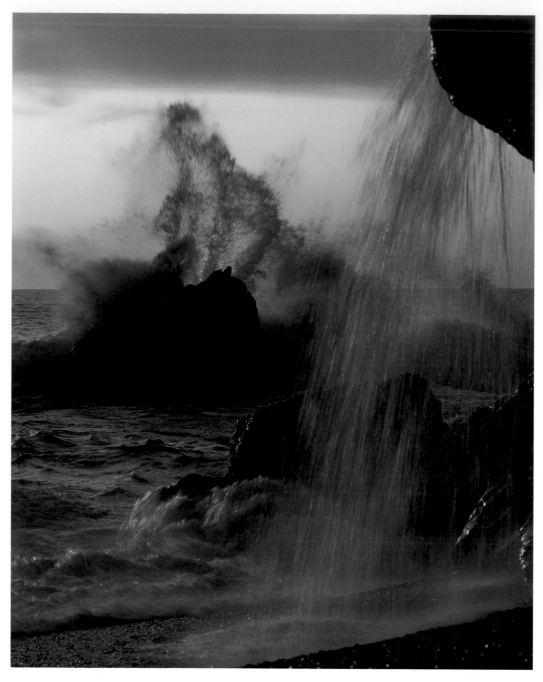

▲ Freshwater streams cascade from the slopes of the
Santa Lucia Mountains onto the wave-sculpted
rocks of Big Sur's precipitous coast.

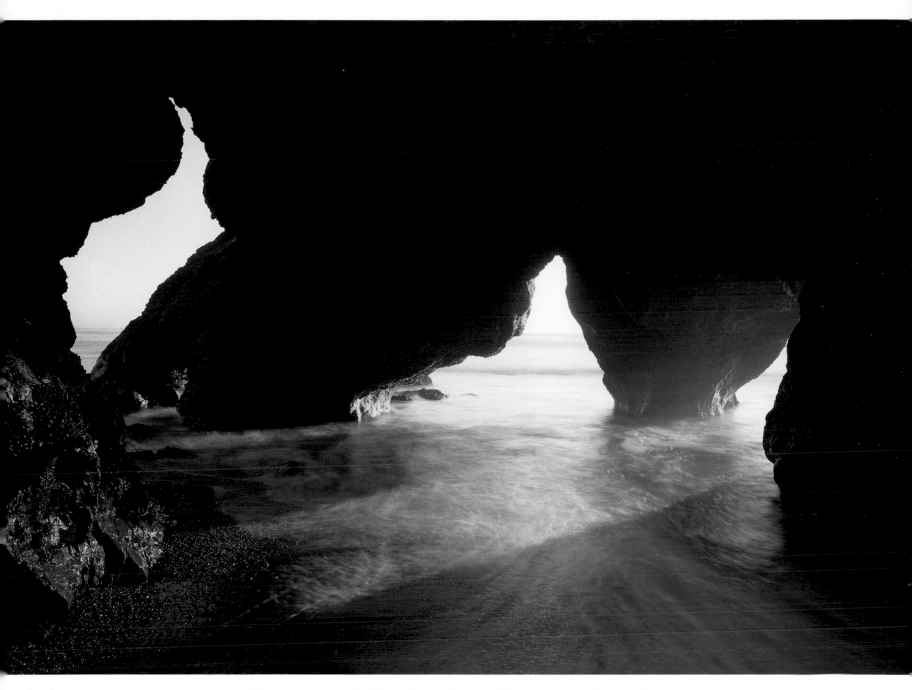

▲ These openings at Needle Rock in Sinkyone Wilderness State Park, along the
Lost Coast and King Range, Northern California, hint at a wild and diverse
terrain of forest, prairie, and coastal bluffs with unspoiled beaches.

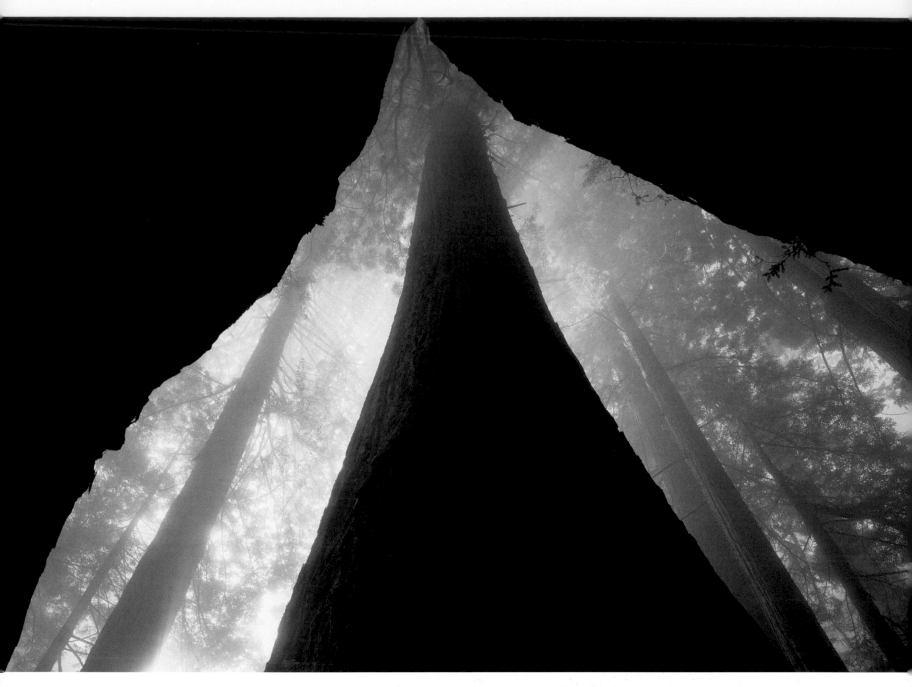

▲ The negative space created by the trunks of towering sequoias is filled
with a foggy translucence of neighboring trees in the Del Norte
Coast Redwoods State Park, an integral part of Redwood
National Park near Crescent City, on the North Coast.

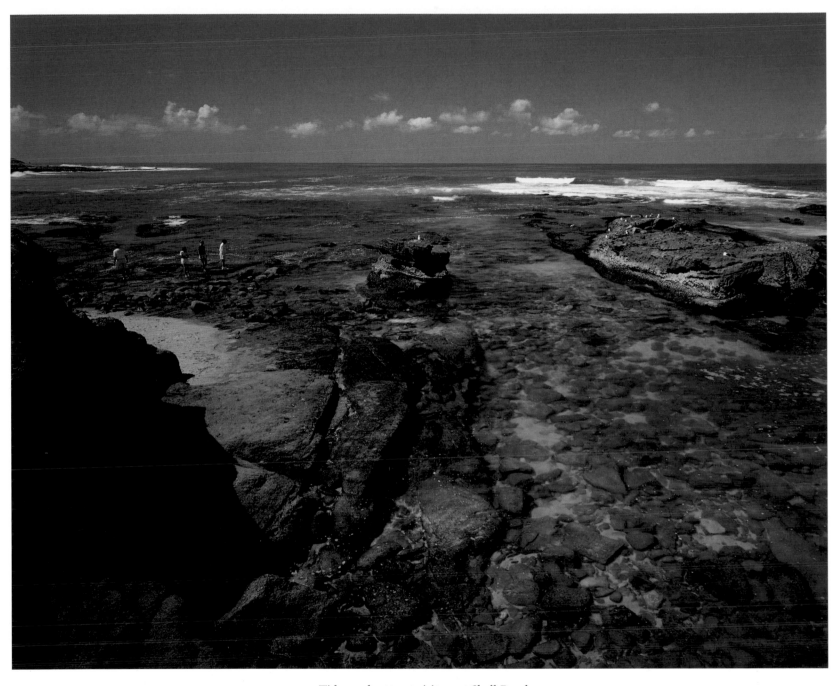

▲ Tide pools attract visitors at Shell Beach
along the La Jolla coast.

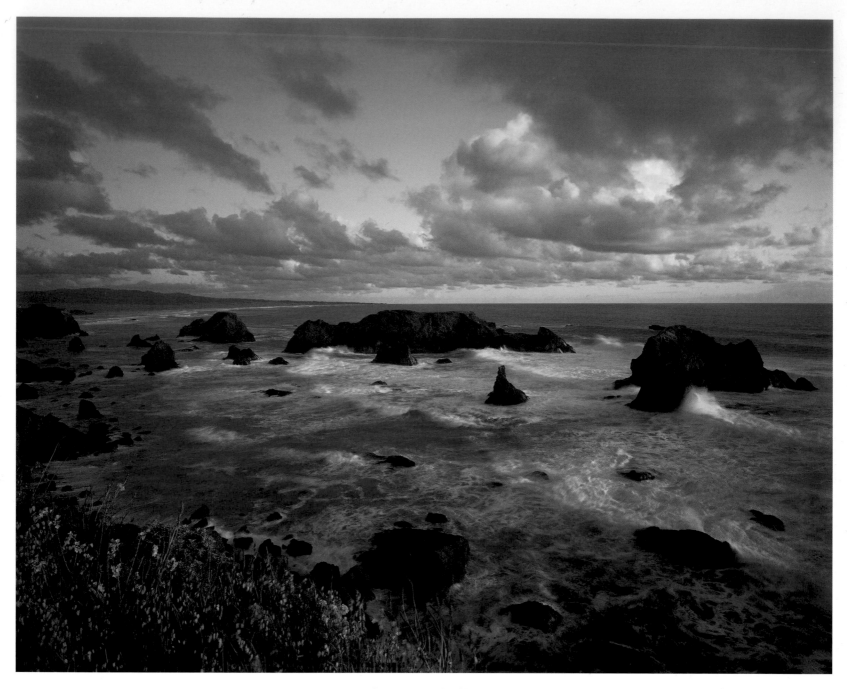

▲ MacKerricher State Park offers an evening
view of distant Laguna Point along the Mendocino Coast.
▶ The eternal drama of sea and land plays out with classical
vigor along Point Reyes National Seashore.

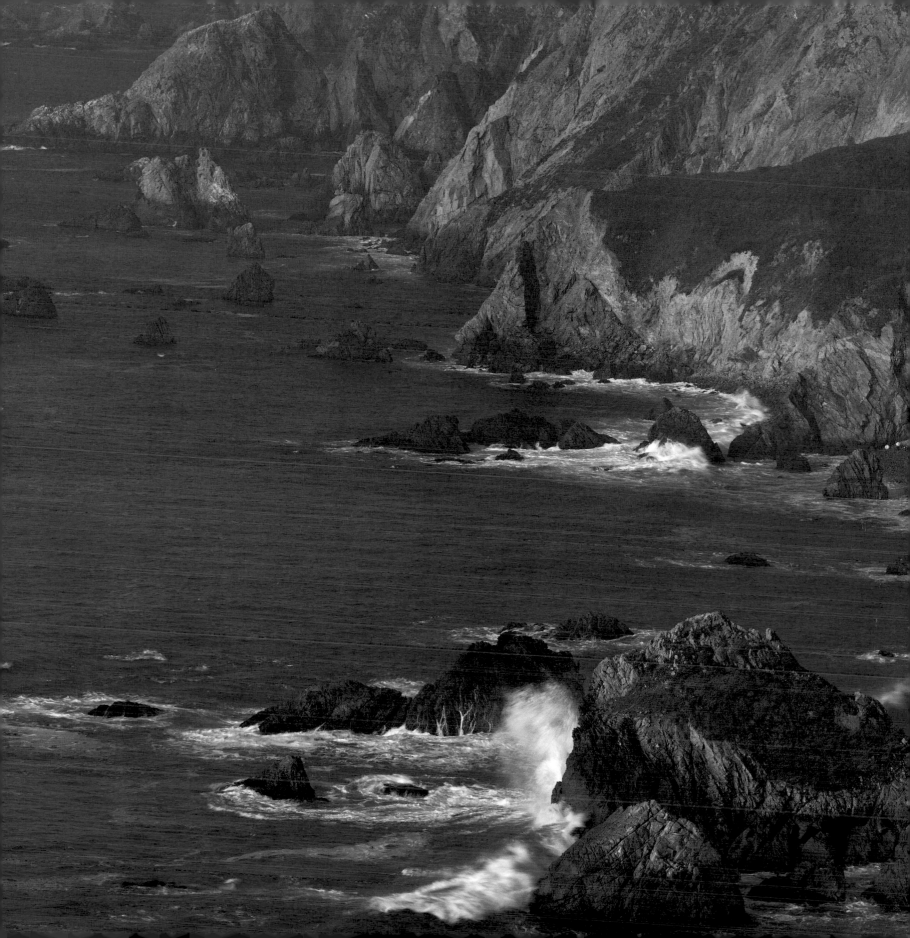

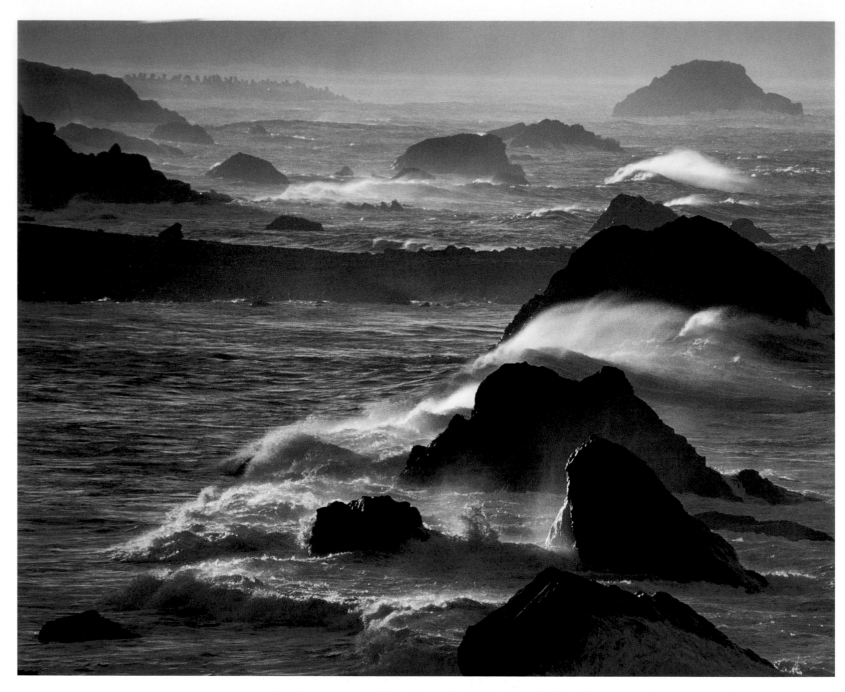

▲ Pacific waves are held back by a double barrier of rock and
offshore winds at Battery Point in Crescent City,
above Redwood National Park.

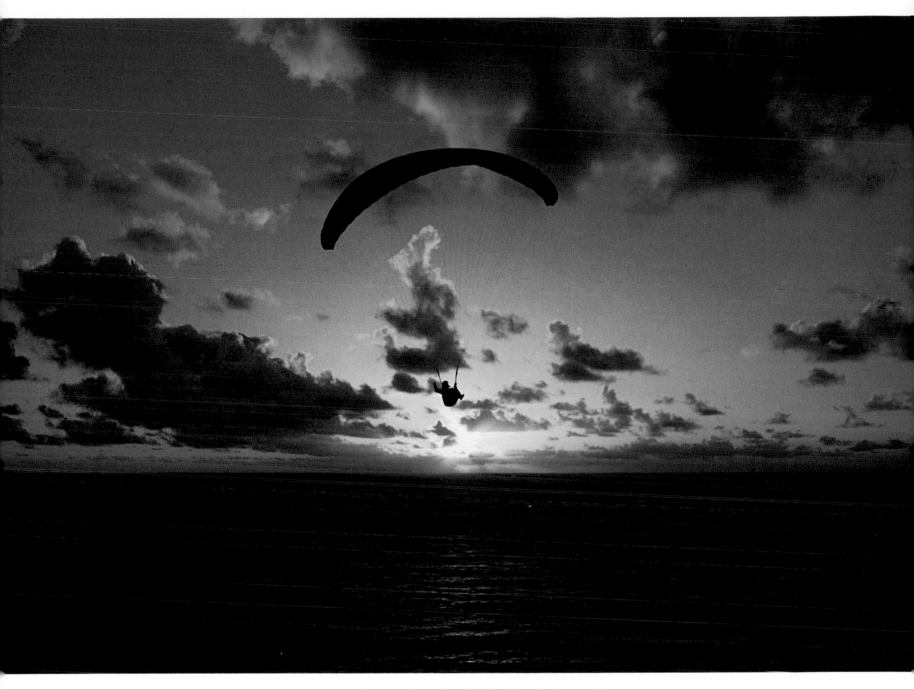

▲ A lone paraglider soars his collapsible "bag" in the last uprising winds of a summer day along the bluffs at Torrey Pines "airport." Only hang gliders and paragliders are allowed to fly at Torrey.

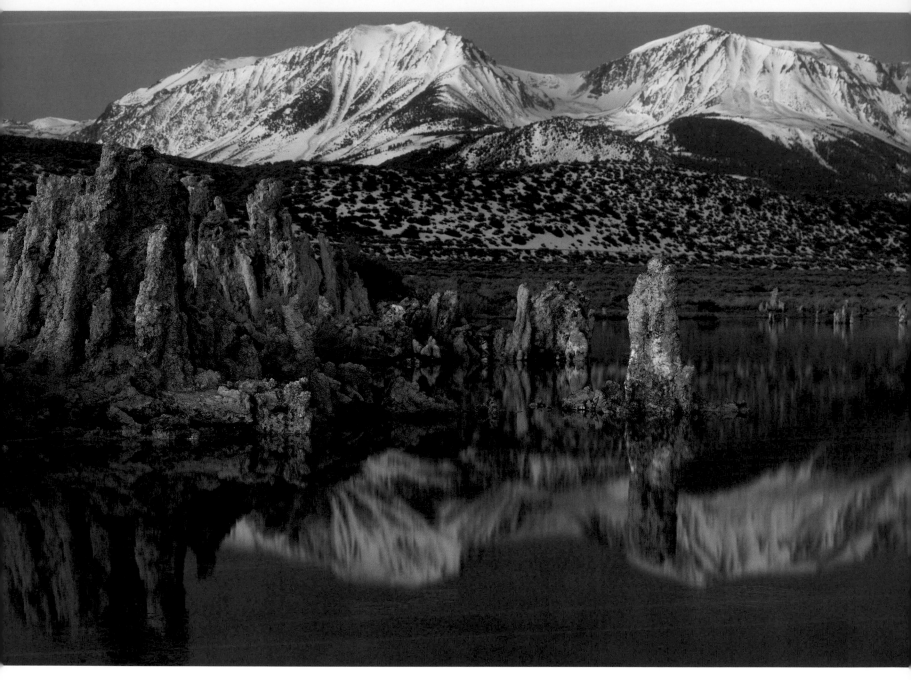

▲ Chemically formed by infusions of mineral-rich fresh water into
the highly saline Mono Lake, ancient tufa formations stand a ghostly vigil.
► CLOCKWISE FROM TOP LEFT: ◗ Joshua trees soak up sun in Joshua Tree National Park.
◗ Badwater reflects the brilliant cirrus clouds in Death Valley National Park.
◗ A plank supports an outhouse in the mining ghost town of Bodie State Historic Park.
◗ Pictographs are found in the Laguna Mountains of Anza-Borrego Desert State Park.
◗ Morning light shines on primrose and Eureka Valley dunes in Death Valley National Park.

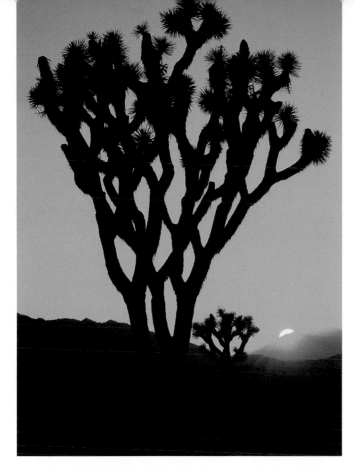

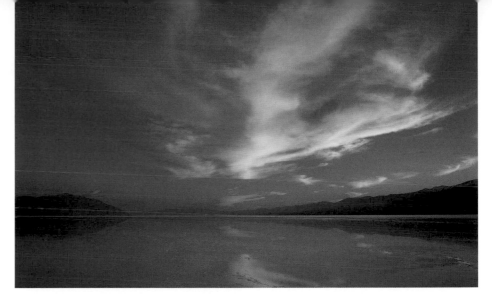

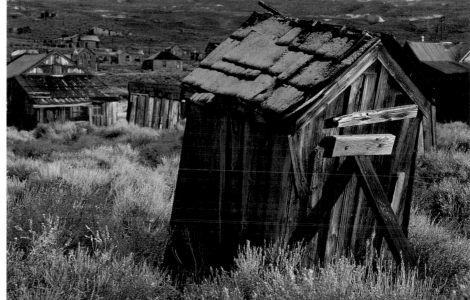

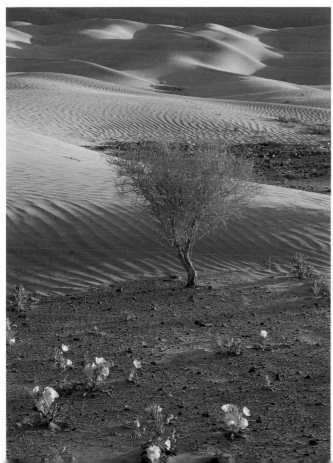

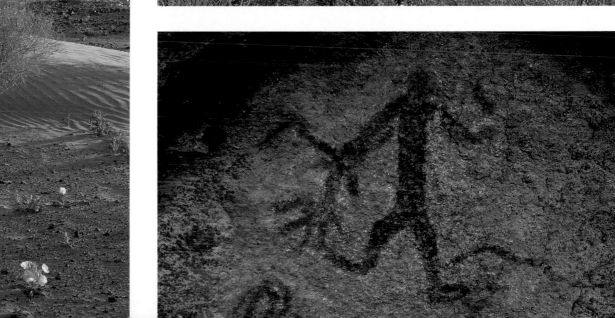

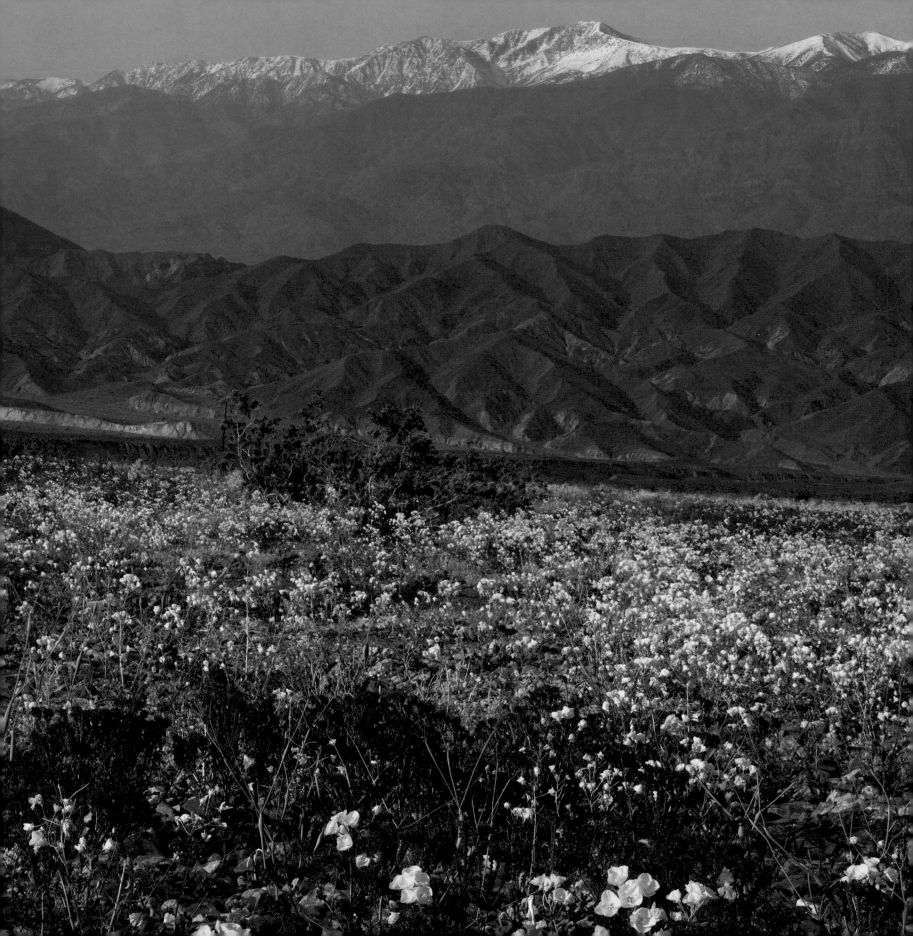

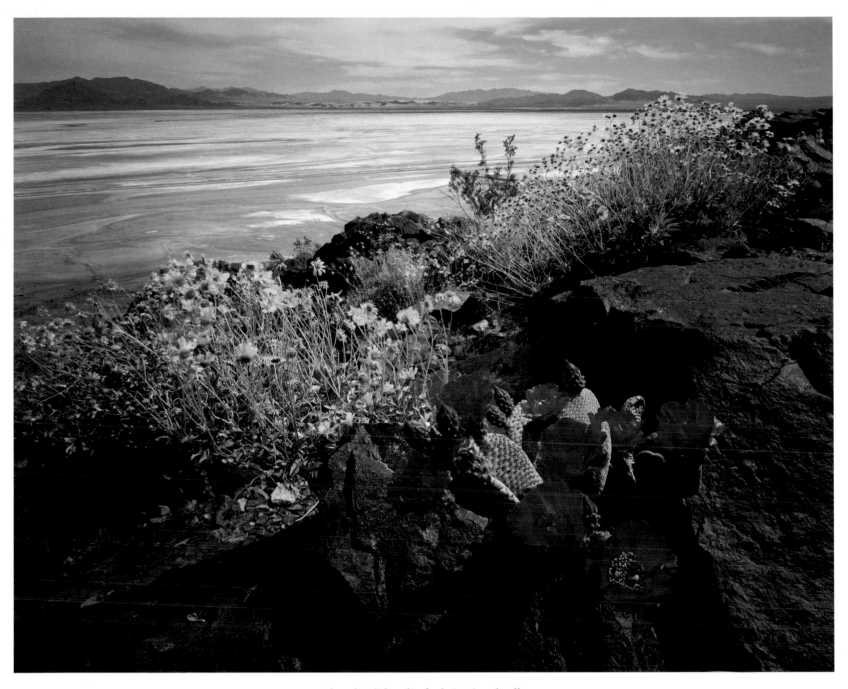

◄ Phacelia *(Phacelia fimbriata)* and yellow
primrose *(Oenothera macrocarpa)* brighten the alluvial soils
of Furnace Creek Wash. The Panamint Range overlooks Death Valley.
▲ April clusters of brittlebrush *(Encelia farinosa)* and beavertail cactus
(Opuntia basilaris) send up a spring rainbow from the arid
expanse of Devil's Playground, Mojave National Preserve.

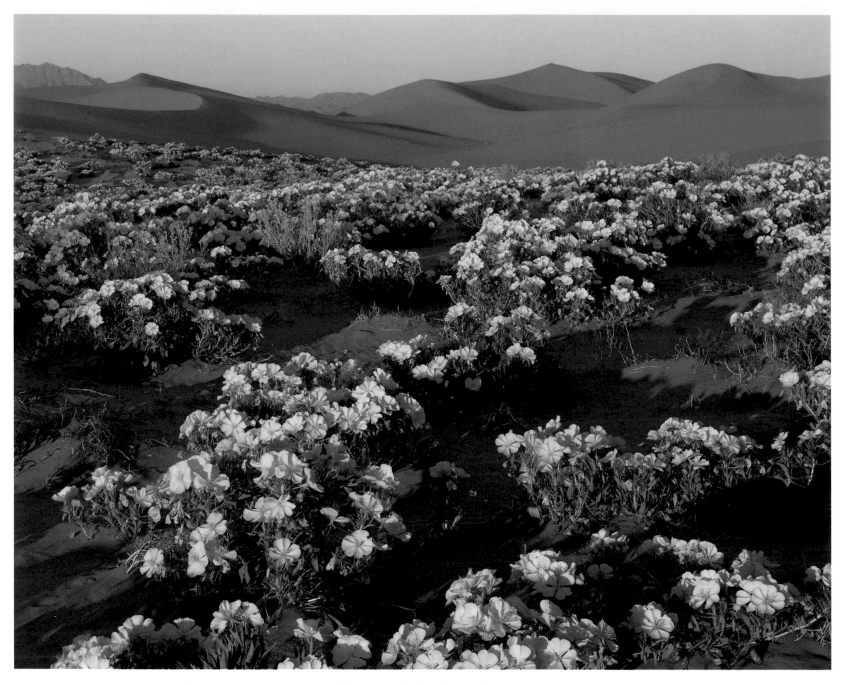

▲ A fragrant blush of dune primrose
(Oenothera deltoides) carpets the desert dunes of Cadiz Valley.
► Telescope Peak (11,049 feet) reverberates in the briny waters of aptly
named Badwater in Death Valley National Park. At 282 feet below
sea level, it is the lowest elevation in North America.

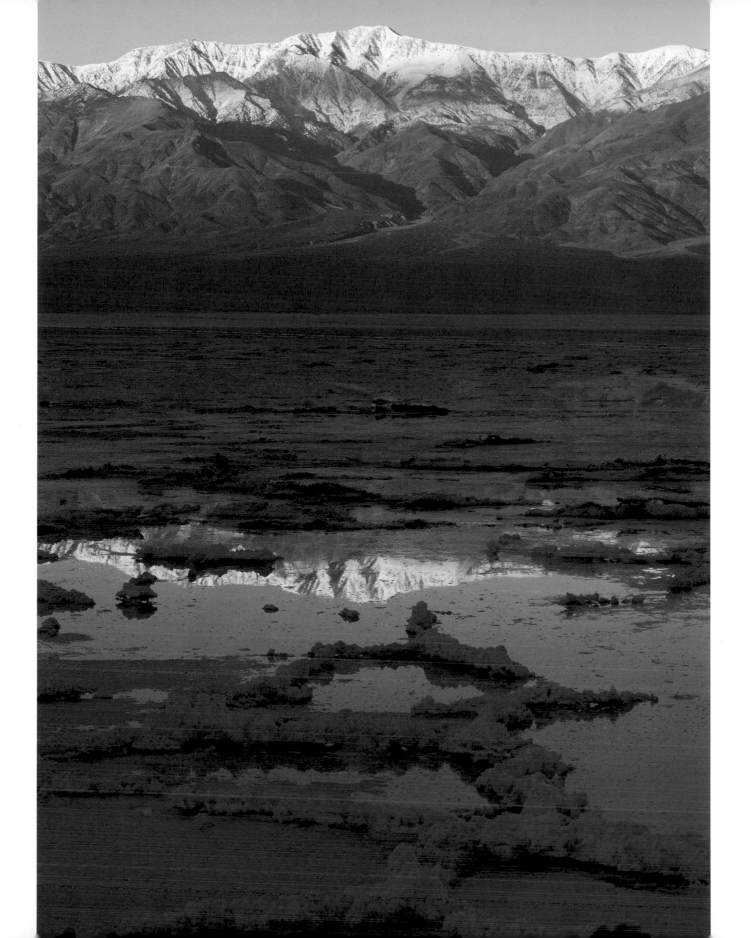

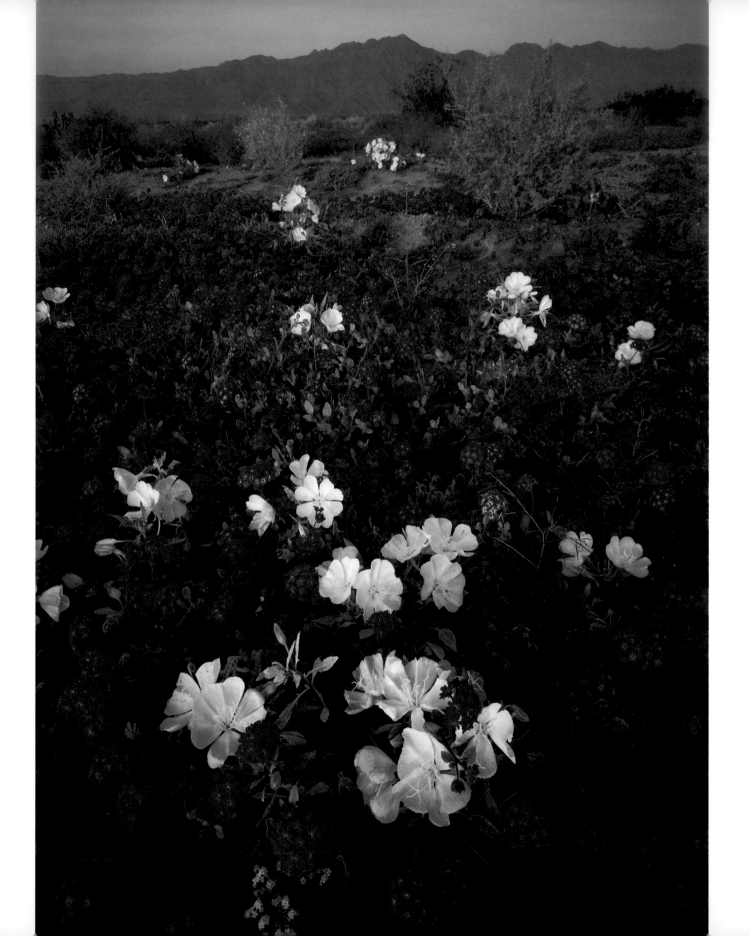

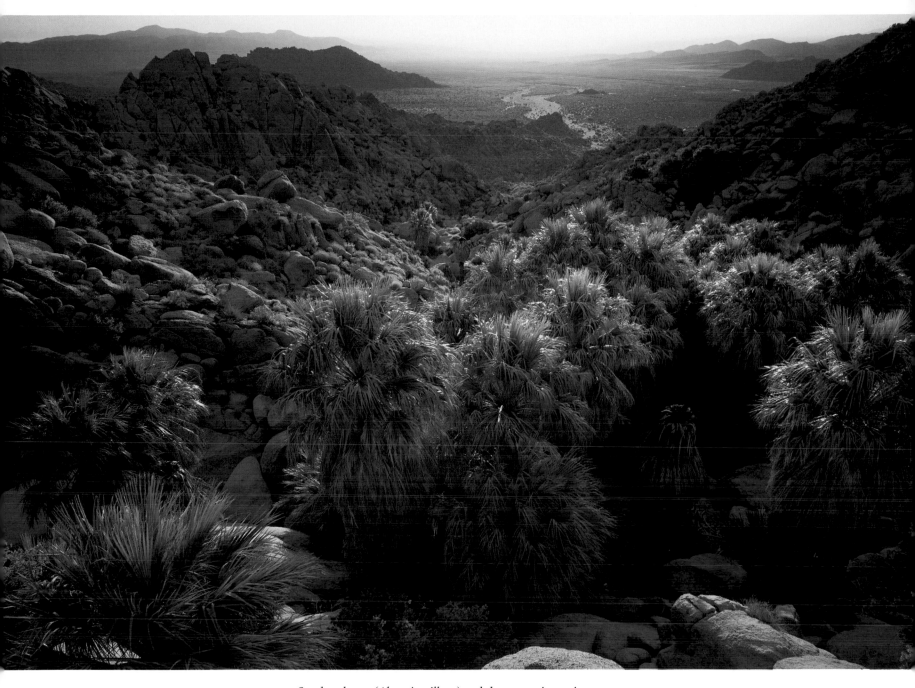

◄ Sand verbena *(Abronia villosa)* and dune evening primrose
flood the desert of Borrego Valley with pink and violet exuberance in
dawn's first light, San Ysidro Mountains, Anza-Borrego Desert State Park.
▲ The Mortero Palms Oasis and its large grove of California fan palms make
for a joyous symphony of morning bird and insect songs at the base
of the Jacumba Mountains Wilderness, Colorado Desert.

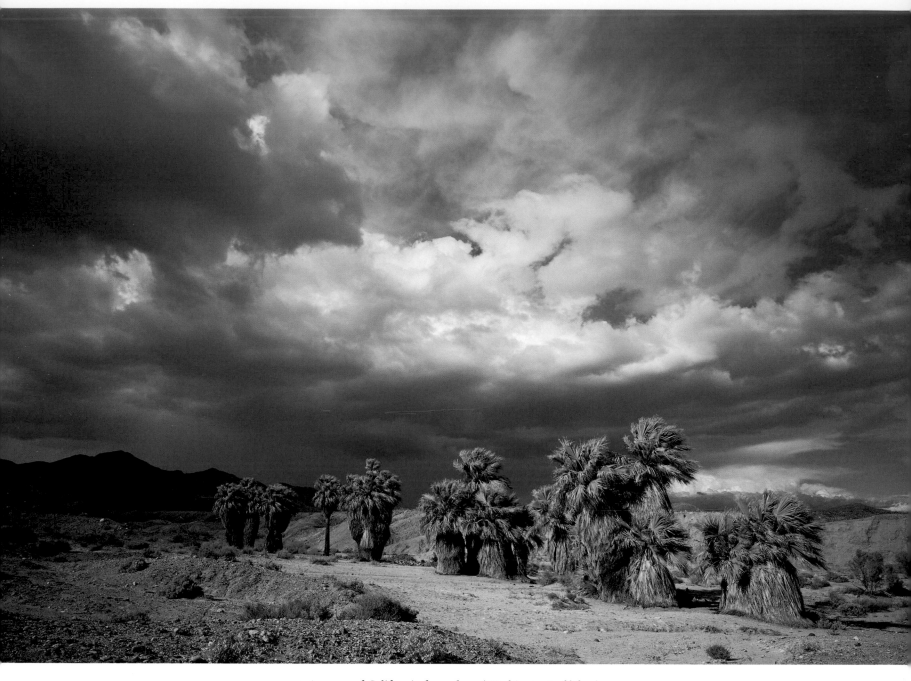

▲ A grove of California fan palms *(Washingtonia filifera)* seems
to dance in anticipation of an approaching storm. The grove makes up
the Seventeen Palms Oasis, nourished by an underground
spring in Anza-Borrego Desert State Park.

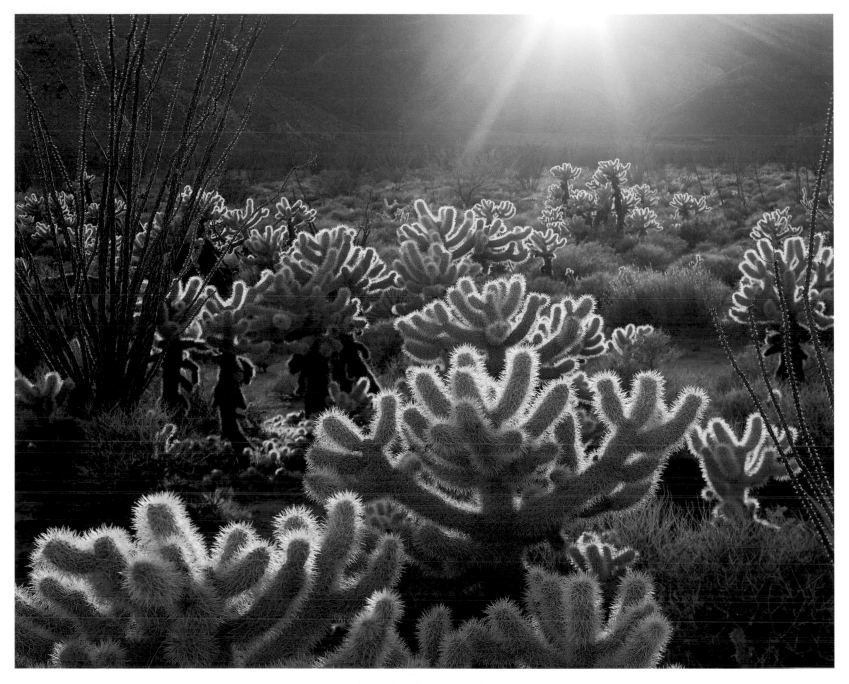

▲ A colony of teddy bear cholla cactus
(*Cylindropuntia bigelovii*) glows in the last rays of
sunlight in Vallecito Valley, Anza-Borrego Desert State Park.
▶▶ Winds blow over the crest of the Eureka Dunes
in Death Valley National Park.

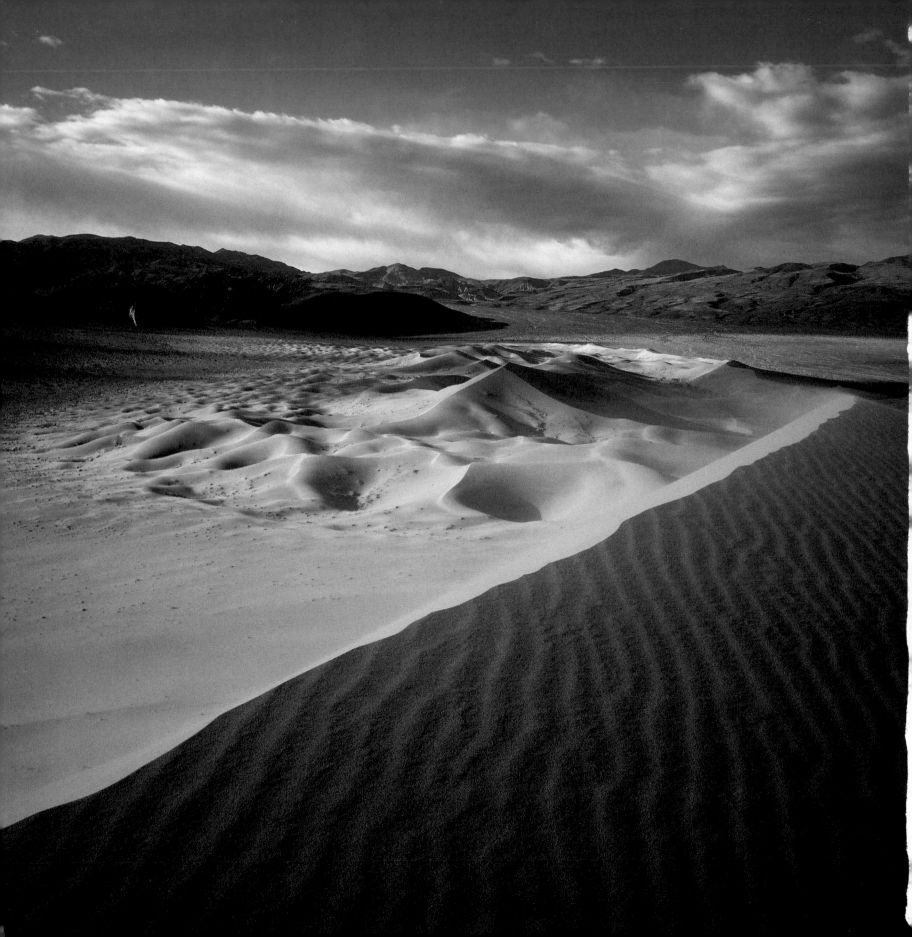